Freaks!

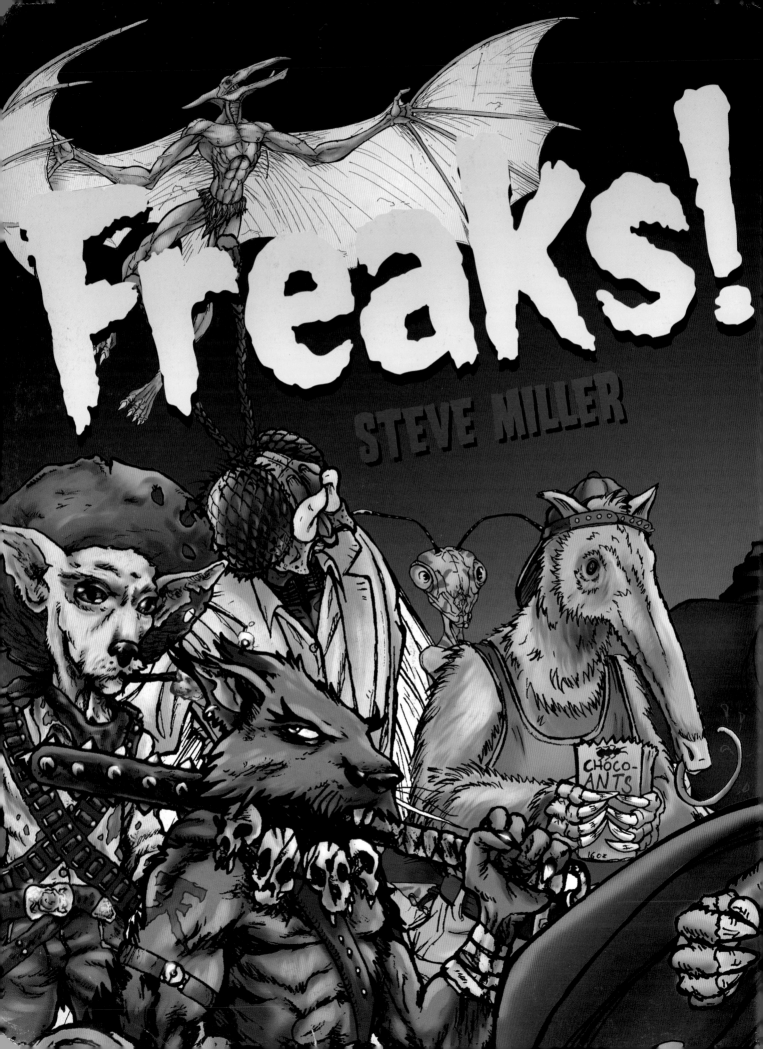

How to Draw
Fantastic Fantasy Creatures

Watson-Guptill Publications
New York

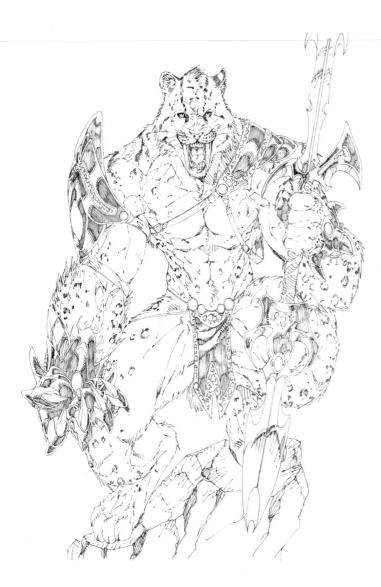

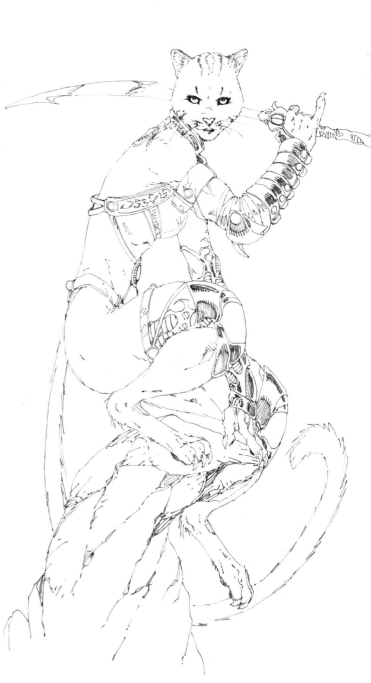

ISBN: 0-8230-1662-5

First Published in 2004 by Watson-Guptill Publications,
a Division of VNU Business Media, Inc.
770 Broadway, New York, N.Y. 10003
www.watsonguptill.com

Library of Congress Cataloging-in-Publication Data
for this title may be obtained from the Library of Congress
Library of Congress Control Number: 2004101275 743.87

Printed in China

First printing, 2004

1 2 3 4 5 6 7 8 9 / 10 09 08 07 06 05 04

Senior editor: Candace Raney
Production manager: Ellen Greene
Designer: Jay Anning, Thumb Print

This book is dedicated to my Mom and Dad, who let me read way too many comic books and watch far too many sci-fi and horror movies.

Special thanks go to Jeff Luttrell for permission to use his wonderful characters Razor and Gizmo, Shawn Kirkham for Elephantaur, Andy Smith for answering my numerous questions, the Columbus Zoo for their assistance with research, the members of Eastside Vineyard Church for their love and support, and Brent VanVlerah for his eleventh-hour computer support.

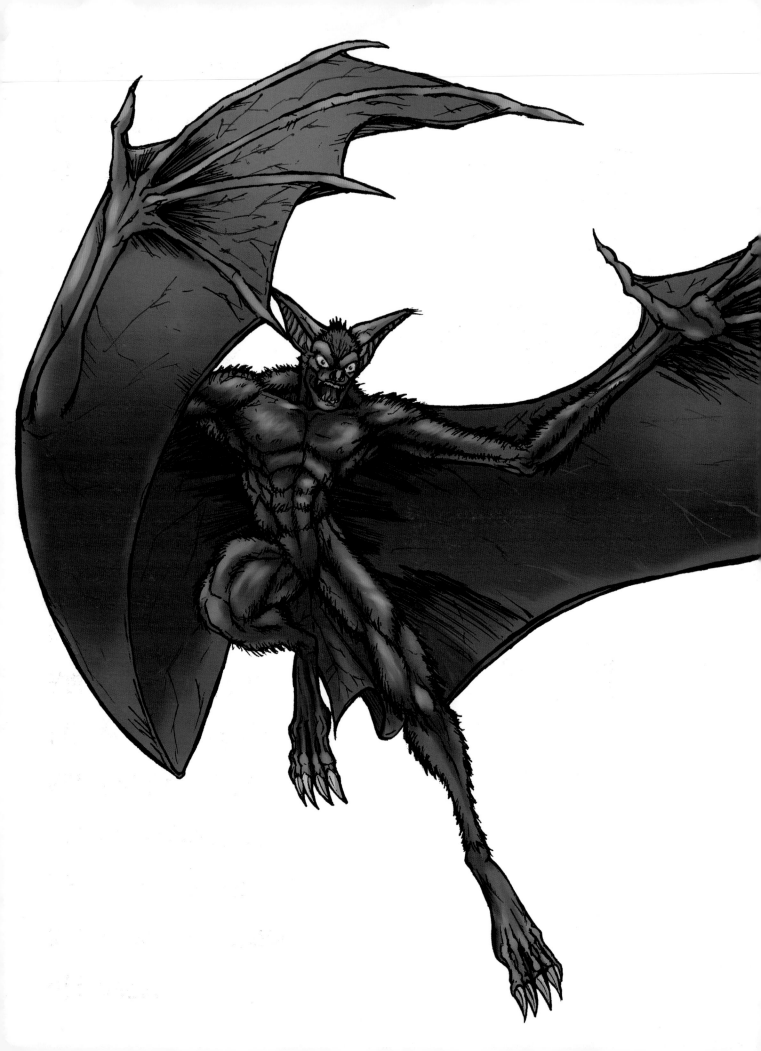

Contents

About the Artists

Arthur Adams exploded on the comics scene in the mid-1980s with his groundbreaking work on Marvel's *Longshot* mini-series. He went on to illustrate the adventures of almost every major comic book hero, including Batman, Superman, Spider-Man, and the Uncanny X-Men, as well as some personal favorites like Godzilla, Gumby, and the Creature from the Black Lagoon. Arthur also created the highly successful *Monkeyman and O'Brian* series for Dark Horse's creator-owned Legend imprint. There is a continuing demand for his work, both from every comic publisher in the business and from collectors.

Bryan Baugh is a young professional artist who works out of Los Angeles as a storyboard artist in the animation industry. He has written and illustrated comic books and children's books, including *Draw Future Worlds* and *Creepy Crafts,* with an emphasis on monsters, horror, and the supernatural.

Brett Booth wrote and penciled WildStorm Productions' *Kindred, Backlash, Wildcore,* and *Backlash/Spider-Man* comic books. He was also the artist on Wildstorm/DC's *Thundercats: Dogs of War* and *Extinction Event.* At Marvel Comics he penciled *Heroes Reborn: Fantastic Four, X-Men Unlimited,* and *X-Men.* He is fascinated by dinosaurs, and has created many wonderful pieces with a paleoart theme. Check out his Website at demonpuppy.com (and be sure to visit the forums, home of one of the friendliest online communities around)!

Jessica Ruffner Booth is one of the most sought-after colorists working in the comics field today. She has been the colorist on comic books for Marvel and Image, including *Backlash, Gen13, Backlash/Spiderman, Wildcore,* and *Heroes Reborn: Fantastic Four.* In her spare time she likes to paint portraits of her 17 dogs.

Mitch Byrd's pencils have enhanced numerous comics from DC, Dark Horse, Valiant, and Verotik. He is a highly regarded illustrator of heroic musclemen, voluptuous women, hi-tech machinery, and thundering dinosaurs.

Steve Hamaker is Jeff Smith's hand-picked colorist for Cartoon Book's *Bone* series as well as for Jeff's upcoming *Shazam* work for DC Comics. Steve is a highly skilled graphic designer who works in the gaming, comics, and toy industries. He has also written and drawn his own comic book, *Fish N Chips.* Check him out at fishnchipcomics.com.

Steve Miller has worked for over 12 years behind the scenes in various entertainment fields including gaming, videos, toys, and comics. Steve lives in the Columbus, Ohio, area with his wife and two kids. Visit him on the Web at www.illustratorx.com.

Todd Nauck started his comics career at Extreme Studios. He then did some work for Marvel, Dark Horse, and Dark Horse, and he penciled the entire 55-issue run of DC's *Young Justice.* He is also the artist/writer for his creator-owned series *Wildguard,* published by Image Comics. Visit him at his Website: toddnauck.com.

The colorists for the art in this book were **Steve Hamaker, Steve Miller, and Jessica Ruffner Booth.**

From the Author

I talk to people all the time who say, "I can't even draw a straight line." My standard tongue-in-cheek response is, "Why not? Don't you own a ruler?" Of course I know what they really mean is that they don't believe they have the talent to produce a competent drawing.

It is true that some people are born with a special knack for art, but I think anyone can learn the basic techniques that professional artists use. Most of us needed to go to school to learn how to read, to do arithmetic, and to write in cursive. Once the fundamentals of those processes were taught to us, all we had to do was practice to make them our own. Just as no one without some kind of brain injury is truly tone deaf, no one is totally without the ability to draw.

If you think about some of the great comic book artists of all time, like Jack Kirby, Neal Adams, and Jim Lee, what really separates them from you? Do they have special "art" nerves, muscles, or bones? Are their arms, hands, and fingers formed differently than your own? No. (Though I'd swear the late great Jack Kirby must have been hiding at least two other arms that allowed him to produce such a large body of great work.) Do their eyes work any differently than the ones you have? Probably not. What really separates them is their understanding of how to draw. Think of it this way. You already possess all the physical attributes you need to draw the things you want to draw. All you need is a good understanding of some basic principles. And hours and hours of practice to go with it.

None of the artists in this book are much concerned with "realism" as a goal. They all emphasize what I think of as the "coolness factor," doing whatever they need to to exaggerate character proportions and details for extreme effects. You may have a completely different approach. In fact, style doesn't matter. You will, over time, develop your own.

The most important ingredient in your successful career as an artist can't be bought in an art supply store or learned from a book. It is something you have to bring with you every time you sit down to draw: That is determination. You have to work very hard at being an artist. You must have the self-discipline not to be discouraged by your failures but to learn from them. And believe me, you will experience many failures before you begin to see the fruits of your artistic labors. Also believe that eventually they will come. Think about it this way: No one has ever become a worse artist by practicing and no one has ever become a great artist by not practicing. Remember that and you'll do fine.

INTRODUCTION

Have you ever wished that you had the strength of a bear? The wings of an eagle? The agility and speed of a jungle cat? Or perhaps you are simply drawn to paintings, books, and films about fantastic creatures that are part human, part animal. Either way, you are not alone. *Homo sapiens* have been giving human attributes to animals, and vice versa, for millennia.

The ancient Egyptians worshipped fierce animal deities that looked very like their human creators. In Greek mythology, two of the ancient races, the satyrs and the centaurs, were half man, half beast. Both Greek and Roman gods often assumed animal form when they walked among mortals. In North America and Africa, native peoples created elaborate ceremonies designed to help them assume the powers of indigeneous animals.

It wasn't until the nineteenth century that anthropomorphic characters—that is, animals or inanimate objects with human characteristics—came into their own in written fiction. Anthropomorphic characters may be animals that walk, talk, and act like humans or they may be true hybrids. Examples of the former abound in C.S. Lewis's *Chronicles of Narnia,* L. Frank Baum's Oz books, Kenneth Graham's *Wind in the Willows,* and Brian Jacques's *Redwall* novels, to name just a few. A very recent example of the latter is Ronan, the centaur in the Harry Potter series.

"Funny animal" characters were the first on the scene in modern entertainment media. It all started with Mickey Mouse and the rest of the Disney cartoon cast, but since then animal/human characters from Thundercats to Teenage Mutant Ninja Turtles to the Lion King, and the animation techniques used to create them, have become ever more sophisticated—and ever more popular.

One obvious reason for the abundance of anthropomorphic characters in modern society is one discovered early on by corporate marketing departments: Everyone loves animals. When it was difficult to find a spokesperson who cut across age, race, sex, and cultural boundaries, they turned to the animal kingdom. By creating a lovable animal mascot to represent their products, companies found their way into the hearts, minds, and eventually the wallets of consumers. Part of the charm and mystique of animal characters lies in taking what is essentially animal and using it for humanesque purposes. It is a best-of-both-worlds scenario.

Another reason for putting animal characters in human situations is that it gives creators a less threatening way to deal with difficult and controversial subject matter. If "mere" animals are doing the dirty work, how terrrible can it be? In the 1950s, some of the animal characters in Walt Kelly's famous comic strip *Pogo* were thinly-disguised caricatures of the prime movers in the House on Un-American Activities hearings.

Comic books, graphic novels, and animated films featuring sapient animals have been a mainstay in Japan since the mid-1960s. Over the last two decades the United States has imported from the East a steadily increasing number of manga comics, anime films, and video games populated by hundreds of complex characters that combine human and animal attributes. The influx of animal/human characters into popular culture is at an all-time high, and the trend shows no signs of letting up. These fantastic freaks are most definitely not "funny animals," nor are they larger-than-life comic heroes who have some animal powers but whose form is human, or animal characters standing in for "real" humans. It is high time these popular favorites received their due, and this book is designed to do just that. *Freaks* covers the skills needed to depict anthropomorphic characters originating with Japanese anime and manga as well as their related North American species.

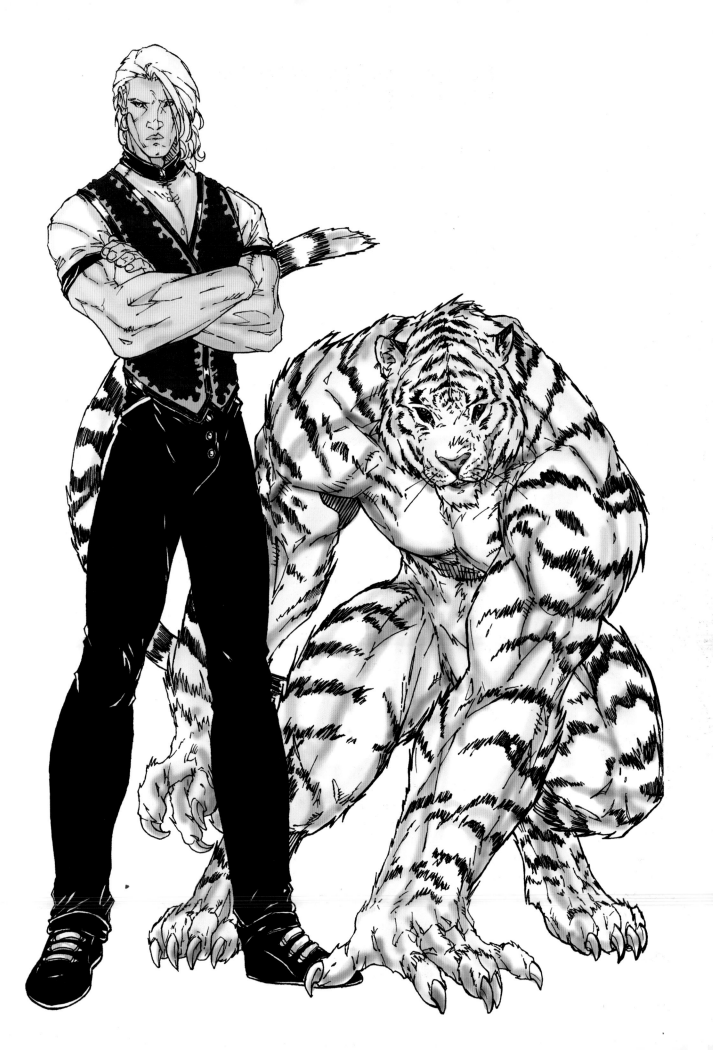

ANATOMY

No, this is not a biology course, but a basic understanding of anatomy is necessary if you want to draw realistic characters. Teaching a comprehensive understanding of anatomy is beyond the scope and range of this book, but I will show you enough to get you off to a solid start. Once you learn the basic building blocks of human—and animal— anatomy, you can set off to morph your figures into fabulously mutated freaks of nature!

Human Anatomy

The human body appears deceptively simple, but in reality it is a complex machine equipped with a huge array of bones and muscles responsible for an incredible range of actions. That's the bad news. The good news is that if you understand the human skeleton, you'll have a "cheat sheet" for drawing the entire figure. If you can draw the skeleton correctly, you have basically solved all the problems of proportion, position, and movement.

The skeletons on the left are the kind you typically see hanging around in science labs and doctor's offices. The two at the right, part stick figure, part anatomy model—are going to become two of your newest friends. Mr. Matchstick, aka the Amazing Simplified Skeleton, and Ms. Matchstick, his feminine counterpart, will ensure that all your drawings have a solid foundation. Artists have given these guys the name "Matchstick" because they looks like they could be built from a book of matches. A bunch of straight lines for bones and circles for joints connecting a few simplified ovals are really all they are.

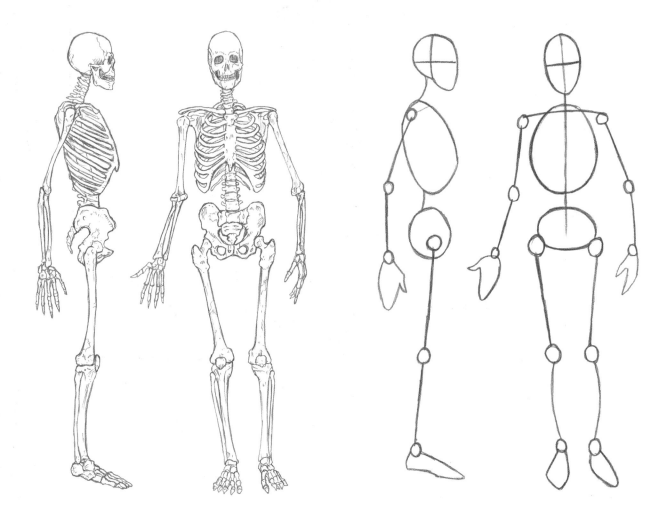

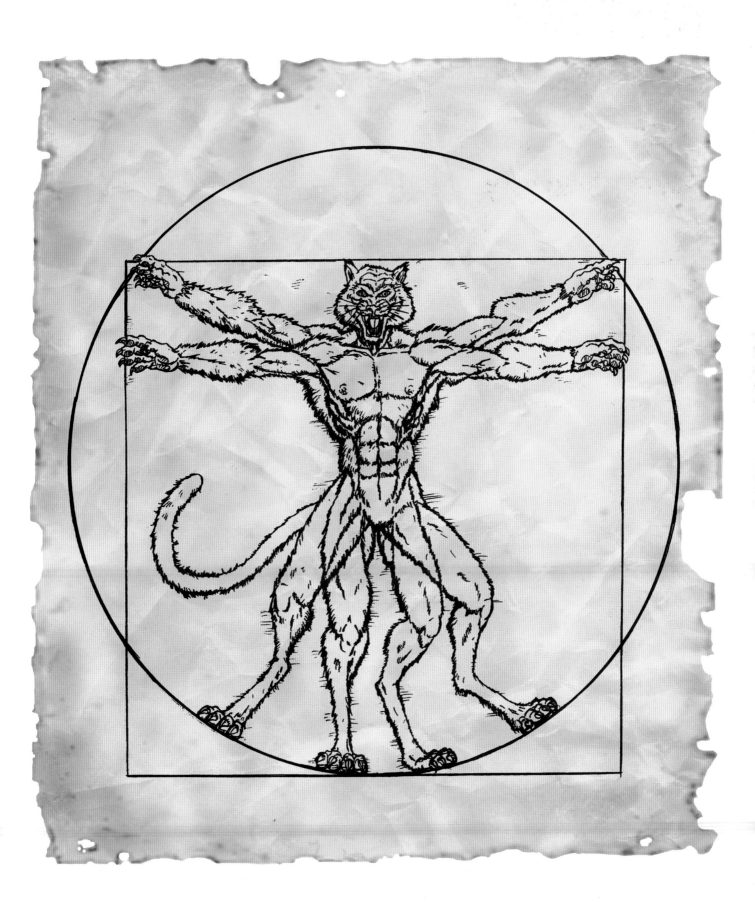

Men versus Women

Men and women may be created equal, but there are some basic differences in their physical makeup, as the accompanying drawings show.

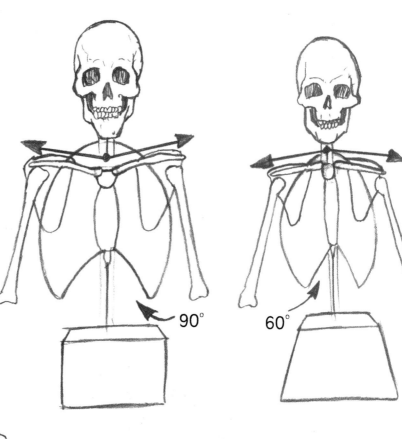

90° 60°

Men's hips tend to be narrower than their shoulders. Women's hips are about the same width as their shoulders. This gives the female form the classic "hourglass" shape. Men have a larger upper body mass than women, and a man's center of gravity is located just below the center of his chest. A women's center of gravity is located in her hips, and this is partially responsible for the swivel-hipped, often graceful gait that women have.

A woman's posture is not as rigid as a man's. A man's chest and hips line up in almost a straight up-and-down line. A woman's hips tilt from the front to back, complementing her torso's tilt in the opposite direction.

▶ Practice drawing Mr. Matchstick in several different positions. Pay especially close attention to the "action line" (in these drawings, the lines that go from the chin to the top of the pelvis oval); it should be loose and fluid, and the first mark you put on the page. All of the direction and motion of your figure should be conveyed in the action line.

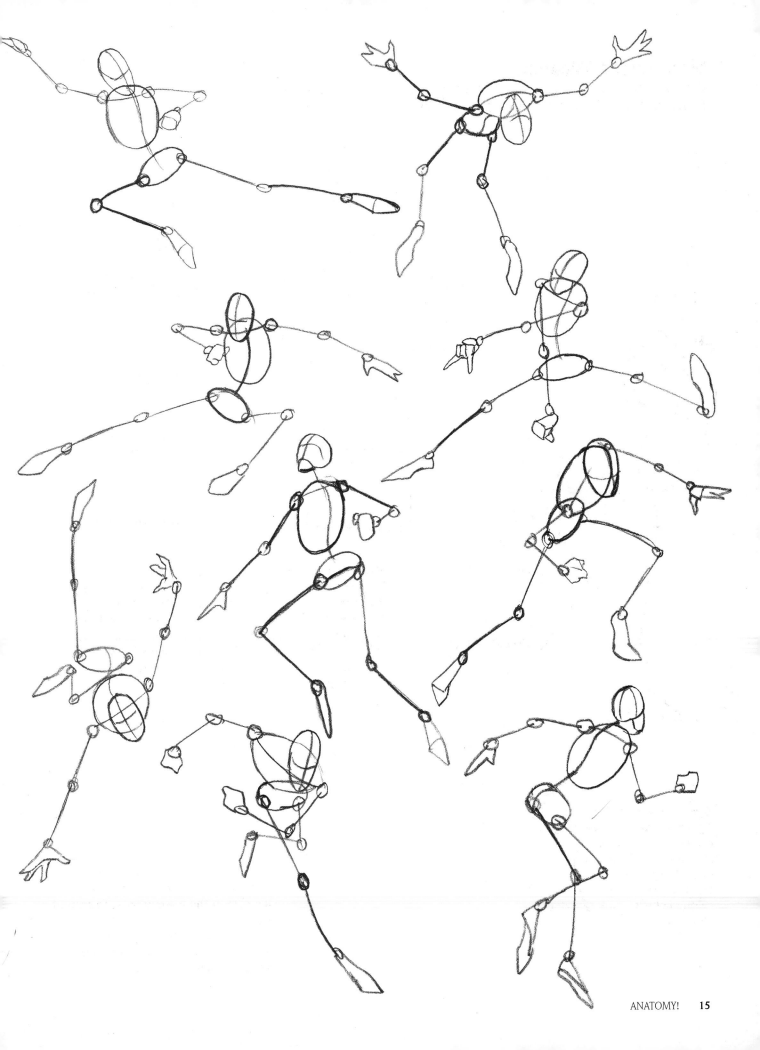

Let's Put Some Meat on Those Bones!
From Matchstick to Mannequin to Muscles

Once you have become adept at drawing Mr. and Ms. Matchstick, it is time to put some meat on their bones—I mean their sticks. There are a couple of different approaches to adding mass to a matchstick person. You can build your figure with simplified cube shapes or you can use rounded forms. My preference is for the rounder, more organic forms, but either will work as a way to begin giving your drawing the illusion of three dimensions. Once the 3D shapes have been added, the figure is usually referred to as a *mannequin.* You can buy artists' mannequins at most art stores, but you can also use any highly articulated toy action figure as a model.

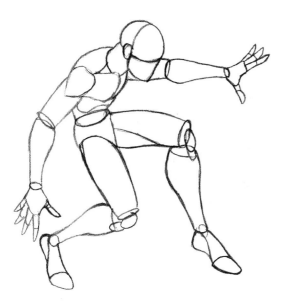

Whatever mood you want your character to be in, the body language should convey it, and you need to establish the basic pose at the very first stage, when you draw your matchstick figure. Is your character menacing? Then be sure to have the feet spread far apart and the shoulders wide. Is your character in motion? Then make sure that the character's center of gravity and line of action are propelling them forward.

Are you trying to convey a somber or mournful mood? Then droop the head and neck and slump the shoulders; the limbs will hang lifeless as if all the energy has been sapped from the character. Not sure what a mood looks like? Step in front of a mirror and do a little Actor's Studio work to get yourself in the right pose for the mood. Or ask a friend to pose. Heck, even if you don't intend to draw them it is a lot of fun to get your friends to assume awkward poses under the false pretense that it's all for art's sake.

The Major Muscle Groups

For our purposes it is unnecessary to learn the names of all the muscles, but you should learn the location and shape of the major muscles groups, the ones labeled in the accompanying drawings. Of course, if you take the time to learn some of the other muscle groups, it will pay off when it comes time to draw outlandish animal characters. Many of the muscles found in people are found in animals as well.

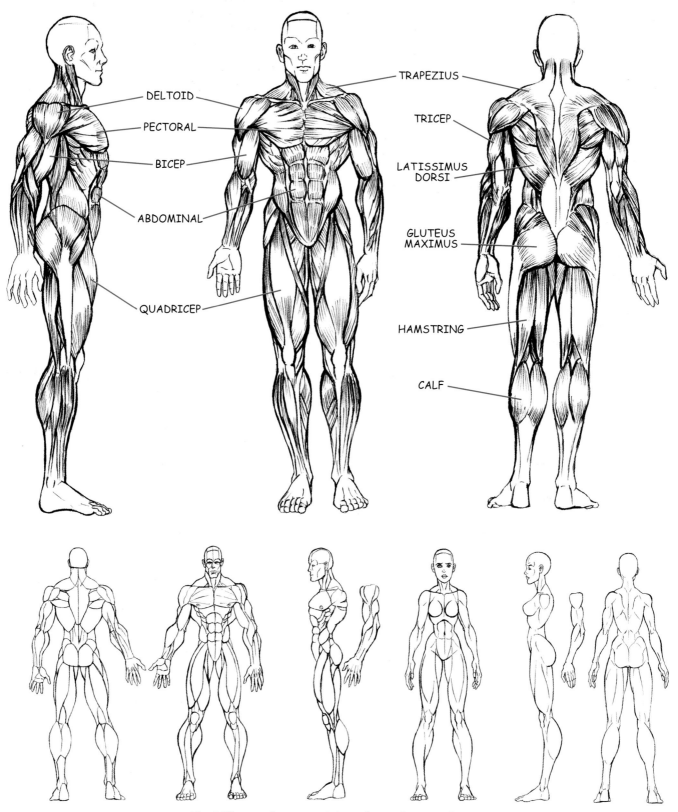

DELTOID

PECTORAL

BICEP

ABDOMINAL

QUADRICEP

TRAPEZIUS

TRICEP

LATISSIMUS DORSI

GLUTEUS MAXIMUS

HAMSTRING

CALF

The Difference between Male and Female Musculature

Supersimple Anatomy

When I started out trying to draw the human figure I used to get hung up on all the little details of anatomy. I couldn't draw legs because they were just too complex. I mean, there were *dozens* of muscles and bones to get right. Where was I to start?

My high school art teacher showed me a different way to "think" about drawing complex shapes. Instead of drawing something complex like a leg, substitute some simpler form to take its place. Can you draw an egg, a tin can, a pillow, a baseball bat, a mitten, a box, a cigar, an upside-down bowling pin, and a door wedge? Yes? Well then you should be able to draw the human head, neck, chest, arm, hand, thigh, calf, and foot. The human thigh became much simpler to draw when I stopped thinking of it as a complex piece of anatomy and started thinking of it simply as a modified cigar. Are you having trouble drawing the chest? Get yourself a pillow, set it up as if it were a model, squeeze it in a little below the center, and practice drawing its simple three-dimensional form. Once you understand the basics of pillow drawing, modify its shape to give it a more chestlike appearance.

The key is to start with something simple you can grasp, then move on. Spend hours working on the separate components, mastering them individually. Practice drawing a mitten (for the hand) before moving on to the baseball bat shape (for the forearm.) Then spend more time combining the two to learn the movements of the wrist. Once you can draw a reasonably decent arm, connect it to your pillow shape.

The key to successful anatomy drawings is always to move from the simple to the complex. Learn the basic structures before trying to render anatomically correct muscles.

Meet Mr. Bubbles. The oval and cylinder shapes here are a little like stacked-up soap bubbles, and, like bubbles, they are translucent so you can see through them. By drawing through objects you ensure accurate placement of all your shapes. Again, this section only covers the tip of the iceberg when it comes to what there is to learn about anatomy. Feed your hunger for improvement with hours of practice in front of a drawing board until you no longer need to look at references for muscle placement.

Find Your Own Style

As you go through this book, you will see that many of the finished drawings are rendered in a style that blends a fairly standard comic book approach with aspects of fantasy art. They are realistic, but not photographically so. The artists have maximized the "coolness factor," exaggerating muscle definition and proportions for extreme effects. Others are done in a more simplified, cartoony style. They are still based on the basics of human and animal anatomical structures, but there are fewer lines and details, and the linework is simplified.

There are also some characters based on the hugely popular Eastern styles: manga (for comic books) and anime (for animated cartoons). As manga itself encompasses many different artists with varying styles it is impossible to adequately describe within a few short sentences. Manga contains aspects of both the traditional comic book style and a more cartoony style of rendering. Characters are often drawn in a youthful simplified fashion, while the backgrounds are rendered with hyper-realism, showing every nut and bolt of machinery and technology.

As you work on developing your own style, don't be afraid to study the work of artists you admire or even to copy directly from other artists. Try to identify what about a particular artist appeals to you, then incorporate it into your own work. As you begin to blend these different elements together you will find your own personal style begin to take shape. An artist's style is constantly evolving and being refined, so do not be afraid to experiment or take your art in a drastically different direction. You are only limited by the boundaries of your own imagination and when it comes to drawing fantastic animal people the wider the boundaries the better!

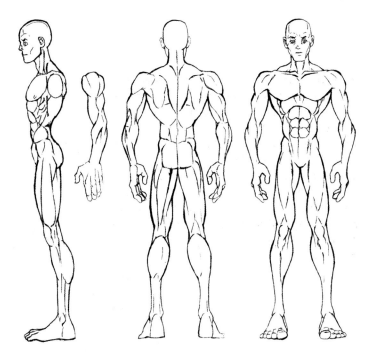

Manga boy's waist is smaller, and his feet and hands much larger, than the waist, hands, and feet of a Western-style comic book character.

These heads show some of the basic differences between standard comic book style and manga. The comics heads are basically realistic, reflecting an anatomically correct skull beneath the skin. The manga head (top row), with its impossibly pointed chin and huge eyes and spare, simple lines, is very different.

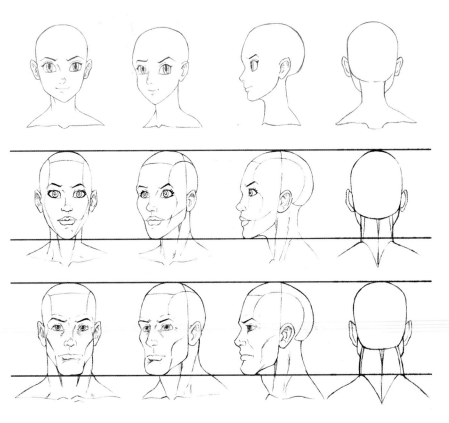

The Animal Element

Before you can design and draw a believable half human, half beast character, you need to learn about some of the basic differences between men and beasts.

Homo sapiens are bipeds. We stand, walk, and run on two legs, in a basically upright position. Most other mammals are quadrupeds, which means they move about on four legs. Primates have only two legs, but when they walk around on the ground, they do not walk upright and the knuckles on their hands touch the ground. Kangaroos hop about on two legs, but, like the primates, are not in an upright position.

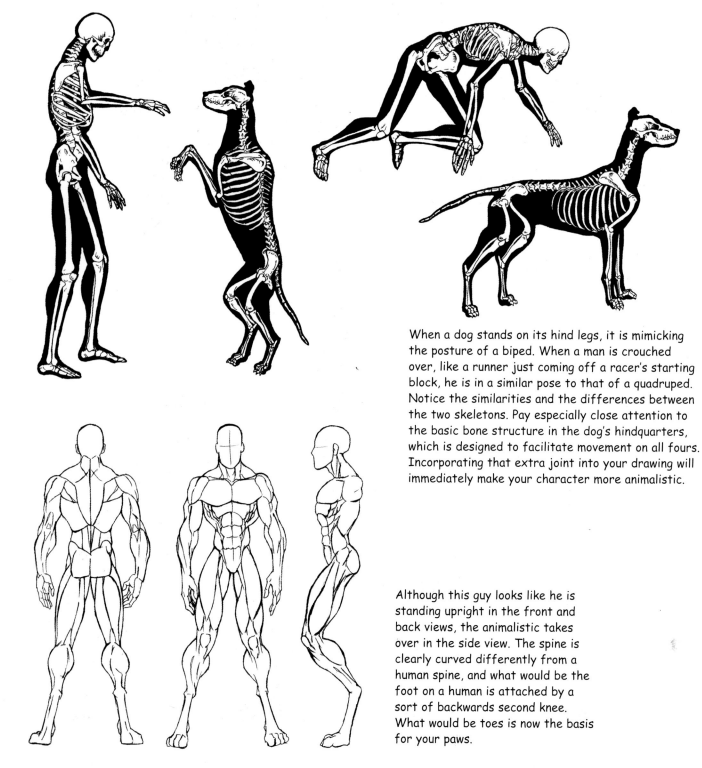

When a dog stands on its hind legs, it is mimicking the posture of a biped. When a man is crouched over, like a runner just coming off a racer's starting block, he is in a similar pose to that of a quadruped. Notice the similarities and the differences between the two skeletons. Pay especially close attention to the basic bone structure in the dog's hindquarters, which is designed to facilitate movement on all fours. Incorporating that extra joint into your drawing will immediately make your character more animalistic.

Although this guy looks like he is standing upright in the front and back views, the animalistic takes over in the side view. The spine is clearly curved differently from a human spine, and what would be the foot on a human is attached by a sort of backwards second knee. What would be toes is now the basis for your paws.

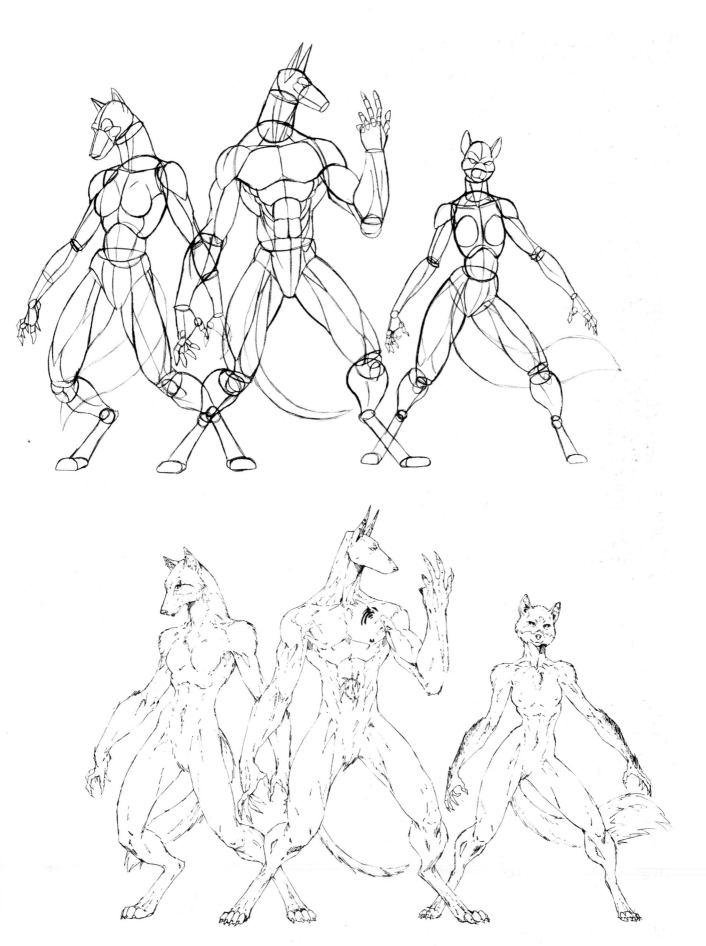

Keeping It Simple

Just as you broke down the human figure into simple shapes, you can analyze an animal-human character in terms of basic, simple geometric shapes.

Just like the simple 3D shapes Miss Clumsy Cat is carrying, her body is made up of 3D shapes as well.

You can use a split cylinder as the base shape for the snout of a dog or cat person. Be sure the center line of the head and the center line of the bottom of the cylinder are parallel. An easy way of thinking about it is to think of your character placing a drinking glass over his mouth, then splitting the glass in two to form the top and lower jaws. Remember to draw through your objects. Draw even the parts that are hidden and may be erased in the final picture. This will help you learn to keep all aspects of your drawings in harmony with each other.

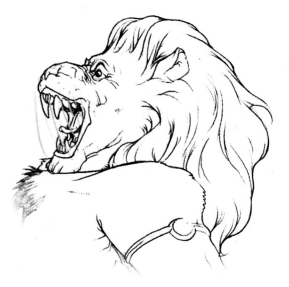

When you get around to doing final drawings for animal characters, if you want to show your character with his or her mouth open, remember that the teeth line up differently, depending on the animal.

From Head to Tail

Mutation, a science experiment gone awry, lycanthropy, cosmic rays. *Something* has transformed your character from a mere human being to a fantastic freak with whatever animal powers you want him or her to have!

As you build off of your basic design you will want to modify your character with the specific traits that distinguish your animal of choice. Whenever possible, study the animal directly from life. If you can't track the animal down live, collect a variety of photo and art references. It is a good idea to practice drawing the animal by itself a few times, in various appropriate stances, before trying to incorporate it into your final character design. This will make it easier to seamlessly fuse the animalistic with the human.

Pay attention to the shape of your animal's snout, tail, wings, paws, claws, ears, fins, fur, beak—all of the physical characteristics that pop into your mind when you think of that animal.

One look at this lady's eyes—especially those pupils—and you know that something animalistic lives deep within.

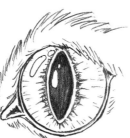

BIG CATS

HOUSE CATS

SPIDER

CHAMELEON

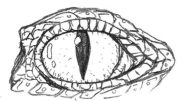

CROCODILE

DUCK

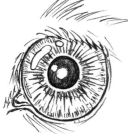

LARGE BIRD

RABBIT

SHARK

The Eyes Have It

The saying "The eyes are windows to the soul" is doubly true for an animal person. Nothing sets a character apart faster than changing the shape and makeup of the eye. Animal eyes come in a wide array of shapes and sizes, not to mention the fact they come in many more colors, including red, yellow, and orange, than the standard human eye. Some animals have extra eyelids and some have a special reflector called a tapetum, which makes them appear to glow in the dark.

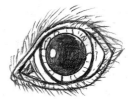

DOG

GECKO

COW

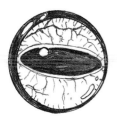

FROG

TURTLE

OWL

LEMUR

GORILLA

If You've Got It, Wag It

A small fluffy tail says your character is gentle and timid like a rabbit, but attach a large scaled tail and your character becomes a ferocious beast. Tails are used mainly for assisting with movement and balance, but a great-looking tail can also be a wonderful design element. Be sure always to sketch in the placement of the tail when doing your initial sketches.

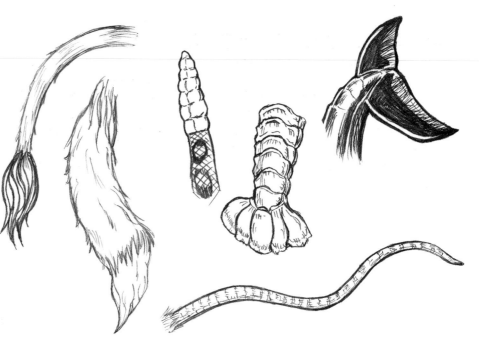

"The Better to Hear You With, My Dear"

As with eyes and tails, there are almost as many different types of outer ears in the animal kingdom as there are species. The outer ear can be almost nonexistent, like the ear holes of lizards, which are flush with the animals' heads, or they can be relatively oversized, echo-catching appendages, like the ears of a bat or kit fox.

They Hear the Call, They Raise a Paw

There are a lot of choices out there. Most of the time you will probably want your characters to have some sort of modified hand that looks animalistic, but at the same time allows them to grasp and manipulate objects. A pair of giant claws may look cool, but you can't use them to button a shirt and they won't fit through a trigger guard to fire a gun. Not to mention what do you do if you get something in your eye? Maybe this explains why so many pirates who had a hook also had an eye patch!

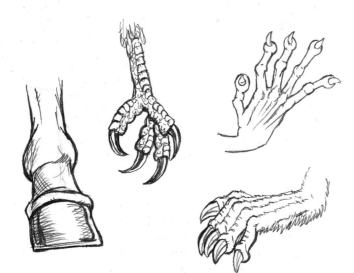

Fins, Fur, Feathers—or Clothes

Nothing but practice and good photo reference material will help you master the many different types of hides, and hide coverings, found in the world of animals. Fur and feathers are best rendered with a fluid motion of the hand. When drawing scales it is best to be observant of uniform shape, size, and patterns of direction. Sometimes drawing every section of fur or scales can give your character quite a striking appearance, but it is not always necessary. Drawing just a few patches of scales or fur will convey the message to the reader that the entire body is covered; this will help keep your drawing from looking cluttered and also save wear and tear on your poor drawing arm!

This is only the match-stick stage, but I made sure to draw in the small circles for the extra joints in her legs. I knew she'd have horns, but I wasn't sure what kind.

OK, she's some kind of bighorn sheep, but I've made her entirely my own. For one thing, her horns are much bigger than ones you would normally find on the female of the species. Her legs, moving from hip to hoof, are represented by cigarlike shapes, stubby bats, and thin cylinders.

I've given her pointy, elfen ears, and the green eyes of a cat. I spent more time drawing the rawhide fringe on her clothes than I did the fur, but those squiggles perfectly convey the rough texture of sheep hair. Actually, bighorns have smoother hair than that, but this one is a creature of my imagination, so I can do anything I want to.

For this character, the artist chose to cover up *all* of her fur. But notice that although she has boots on, the feet within are clearly rabbit feet. She's also a good example of creating a character who *goes* against type. There's no rule that says you *have* to make your fox-man sly, your cat woman a super hunter, or your bear creature big and strong. Sometimes you can make a statement by creating an animal character whose personality is the opposite of how the animal is usually perceived. Think all bunnies are adorable little puffballs to be loved, hugged, and squeezed? Think again. Here is one bunny babe who is tired of being treated like a walking plush toy. She knows she is cute, but she wants people to know she is a real butt-thumper as well. She is lively, a little flighty, and extremely high-strung. She is easily excitable and quick to hop from one extreme to the other. Remember she has a hare trigger, so you don't want to tick her off.

Artist: Todd Nauck

Ms. Husky adheres to what is referred to in the entertainment industry as "the Wookie Rule": A character covered in nothing but fur is not really naked.

WEREWOLVES

Perhaps there is no more famous man-beast then the ever-popular werewolf. Where and when the wild folklore of the wonderful world of werewolves began is hard to say. (I'm serious, try saying the last sentence out loud.) In the Western world, the first written accounts of lycanthropy—the transformation of human being into wolf—are from Greece and Rome. Herodotus wrote of the Neuri, sorcerers who changed themselves into wolves once a year. In *Metamorphoses,* the Roman poet Ovid relates the story of Lycaon, king of Arcadia, who set out to test the omniscence of Jupiter by serving him human flesh. Jupiter, however, was no fool, and he turned Lycaon into a wolf as punishment (and gave us the origins of the word "lycanthropy").

One great thing about wolf people is that they are a global phenomenon. Most cultures have interesting myths and folklore about lycanthropes. Experiment with adding wardrobe flourishes and weapons from other countries. Wolfy here is obviously a world traveler. His head feathers suggest an origin in the American West, but his weapon is most definitely not a tomahawk.

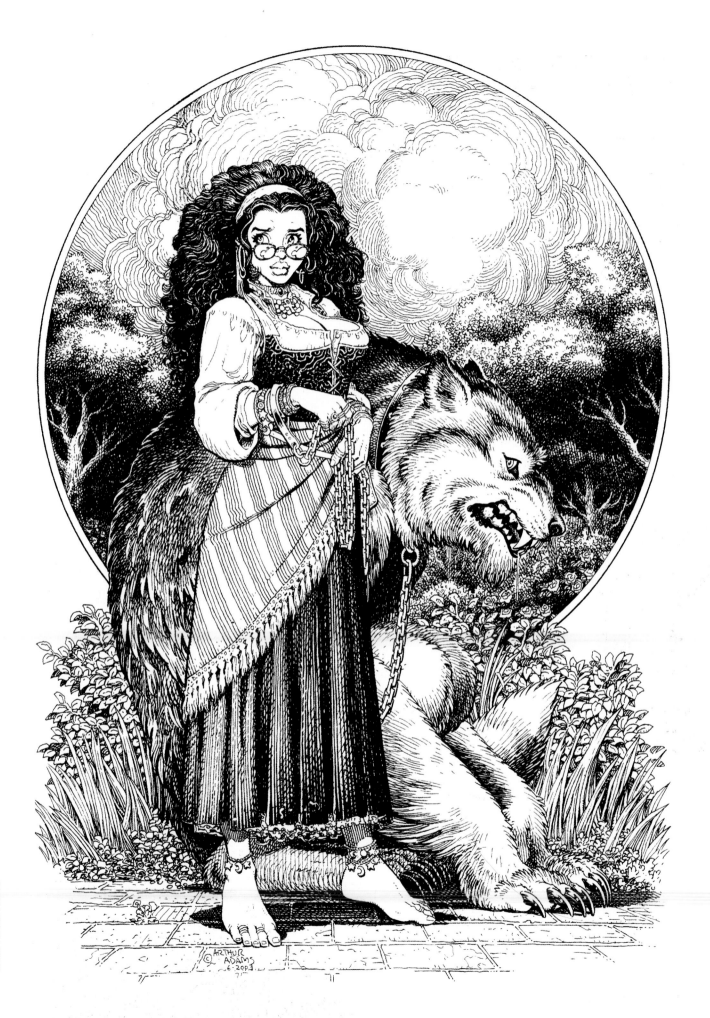

Just how one becomes a werewolf (other than through sorcery or god-inflicted punishment) is hard to pin down. Some early accounts described pagan rituals involving salves and incantations; others ascribed lycanthropy to a genetic disease or a family curse. Superstitions holding that a person has to be bitten by a werewolf to become one, and that lunar cycles control the metamorphosis, are relatively recent additions to werewolf lore.

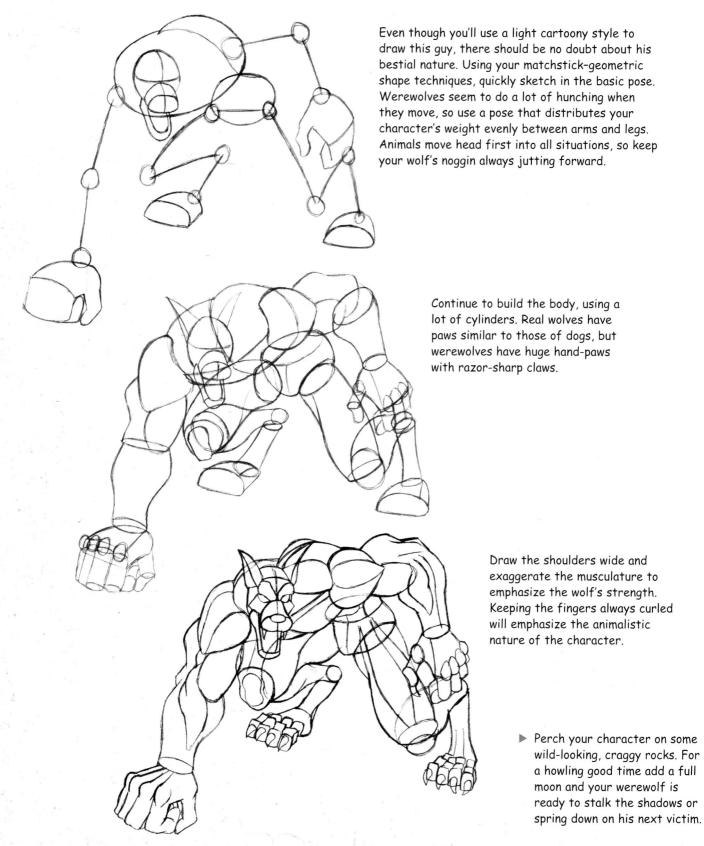

Even though you'll use a light cartoony style to draw this guy, there should be no doubt about his bestial nature. Using your matchstick-geometric shape techniques, quickly sketch in the basic pose. Werewolves seem to do a lot of hunching when they move, so use a pose that distributes your character's weight evenly between arms and legs. Animals move head first into all situations, so keep your wolf's noggin always jutting forward.

Continue to build the body, using a lot of cylinders. Real wolves have paws similar to those of dogs, but werewolves have huge hand-paws with razor-sharp claws.

Draw the shoulders wide and exaggerate the musculature to emphasize the wolf's strength. Keeping the fingers always curled will emphasize the animalistic nature of the character.

▶ Perch your character on some wild-looking, craggy rocks. For a howling good time add a full moon and your werewolf is ready to stalk the shadows or spring down on his next victim.

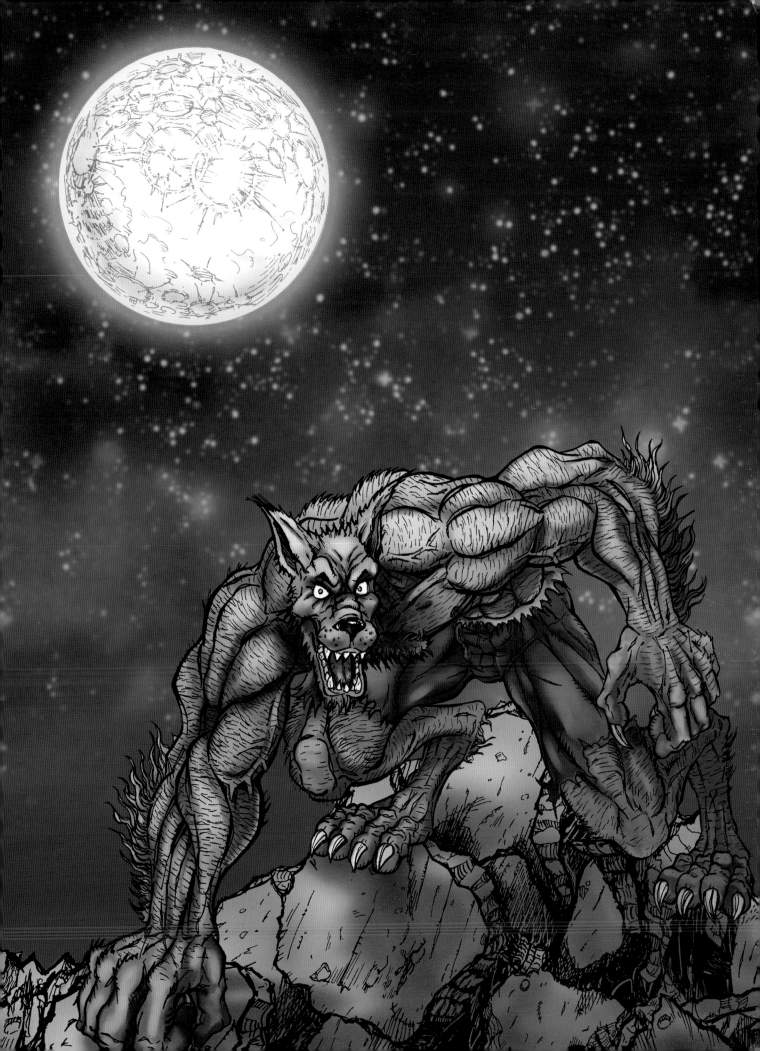

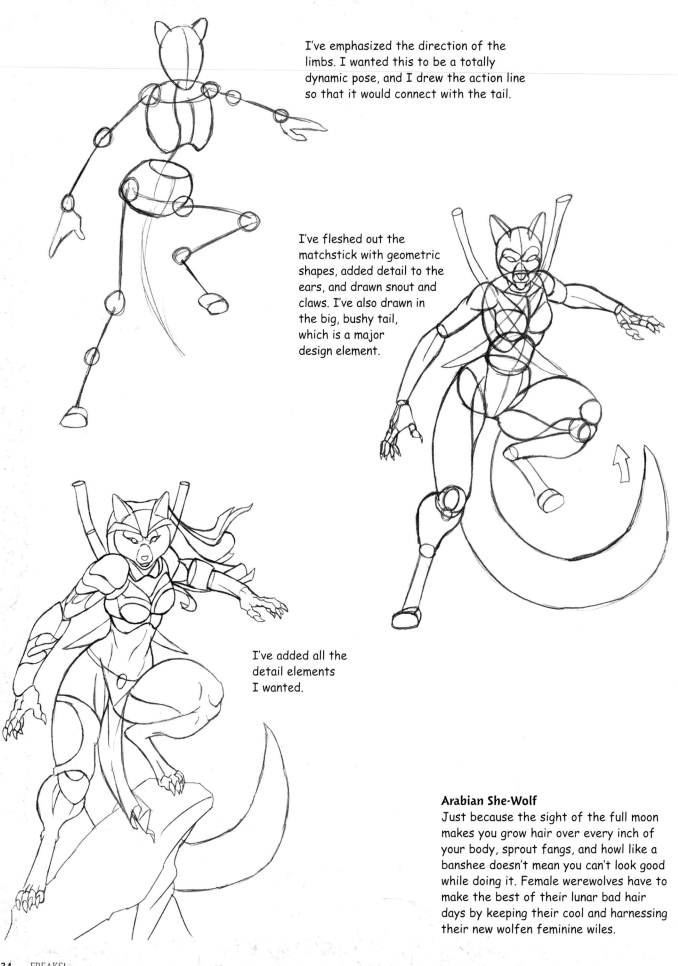

I've emphasized the direction of the limbs. I wanted this to be a totally dynamic pose, and I drew the action line so that it would connect with the tail.

I've fleshed out the matchstick with geometric shapes, added detail to the ears, and drawn snout and claws. I've also drawn in the big, bushy tail, which is a major design element.

I've added all the detail elements I wanted.

Arabian She-Wolf

Just because the sight of the full moon makes you grow hair over every inch of your body, sprout fangs, and howl like a banshee doesn't mean you can't look good while doing it. Female werewolves have to make the best of their lunar bad hair days by keeping their cool and harnessing their new wolfen feminine wiles.

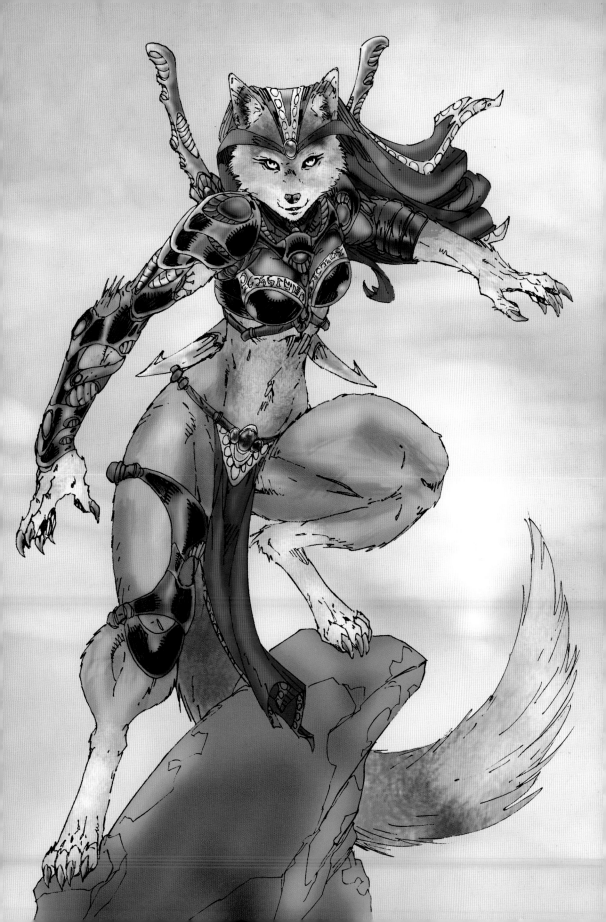

MEOWW!
Cats, Those Fabulous Furballs

Creatures that are part human, part cat don't have nearly the number of screen credits that werewolves do, but there are some memorable fictional examples. The original *Cat People* (1942), about a woman suffering from a family curse who turns into a killer panther at times of emotional extremes, struck a chord with audiences everywhere. In the film the dual nature of felines—feminine and alluring but at the same time darkly dangerous—was masterfully portrayed. Another classic tale of human turned cat (in this case, lion) is Jean Cocteau's *Beauty and the Beast* (1946), a film that, like *Cat People*, is basically a psychological thriller.

Cats have been described as nature's perfect hunting machine, a fierce combination of grace and power. Unlike canines, felines rely mainly on the element of surprise and stealth when they hunt. The cat creeps close to the ground; every movement is precise and silent. Then, with ears laid flat, they attack in one sure, swift motion. If they don't kill their prey by sheer impact, razor-sharp teeth and powerful jaws finish the job.

Jungle cats hunt by night and they hunt alone, and they are widely viewed as being distant, aloof . . . and very, very dangerous. Cats can also be extremely affectionate and playful with each other and with humans. This complex personality mix makes for intriguing possibilities when designing your feline characters.

Meow! She is an agile hunter and a silent stalker. With her double swords she strikes like lightning and moves as silently as the wind. I'm not sure what her name is, but I'm pretty sure she won't answer to a call of, "Here Kitty, Kitty." House cats are really just scaled-down versions of the big wild jungle cats. They share all the same ferociousness and hunting savvy of a lion or tiger, just on a scale that will fit nicely in your lap. They are natural gymnasts so you will want to outfit them with clothes that allow for ease of movement.

Perched high on a rocky crag, this dynamic duo is ready for all comers. If the usual weapons—razor-sharp canines and claws and the latest weaponry—don't do the trick, cat man can activate his ice-beam-shooting power paw and literally freeze his enemies in their tracks.

There are over 35 species in the cat family, and visually, cats are some of the most striking creatures on the planet. Markings range from stripes and spots to rosettes and swirling calicos. The colorization of their pelts includes warm browns, oranges, and tawny golds, as well as cool grays and near black. Many cats have large white patches on their underbellies or muzzles. Their eyes are six times more efficient than our own in the dark. Their ears snatch low-level noises from the air, allowing them to hear even the scurrying of tiny rodent feet. Cats' protruding whiskers also assist in finding prey by acting as a sort of radar detector. When prey is located, cats pounce, using their strong back legs and unsheathing their retractable claws.

When playing mad scientist with the ol' gene splicer you can never be fully sure of what you will end up with. Will you come out more man than animal? Or will you inwardly and outwardly be a snarling beast? You may prefer your characters to be more human than beast, like these guys. The animal elements are mostly cosmetic: changes to the skin and overall body coloring. Not that it is going to make it any easier for these two to find dates come Friday night, but on the upside they are shoe-ins for a touring production of *Cats*!

Tigers

Tigers have everything it takes for a great anthropomorphic character: fantastic coloration, piercing, luminescent green eyes, huge canine teeth perfectly designed for penetrating and tearing flesh, powerful legs, and massive paws. They are terrifying to behold even when they are not on the prowl for prey. The transformation tigers are capable of is truly amazing to behold. When resting or at play a tiger can appear as docile as a house cat, but when provoked, it metamorphoses into a snarling beast ready to fight until the death.

Three of the eight subspecies of tiger—Bali, Caspian, and Javan—have been hunted to extinction. The five remaining subspecies are Bengal, Indochinese, Siberian (also known as Amur, Korean, or Manchurian), South China, and Sumatran. All tigers belong to the genus *Panthera,* more commonly known as the great cats. Tigers are the largest of the great cats, ranging in size from about 7 feet and 165 pounds (female Sumatran tigers) to nearly 11 feet and up to 800 pounds (male Siberians).

Every inch of this tiger's body reflects a savage tension. Zoo animals seldom display the deep levels of agitation and ferocity tigers are capable of. If you want to create a realistic Tiger Man, you'll need to see tigers in the wild—either in the flesh on a safari or on film. Some of the footage in big cat documentaries can be quite violent, but I'm sure you can handle it. Us artist types come from hardy stock.

The markings on the fur of a Bengal tiger are vibrant, lustrous oranges against sable black stripes with white highlights. It was fun creating accessory details that worked with the brilliant basic colors.

Leopards

Leopards, like all cats, are perfect killing machines. They excel at tree climbing and are often found in the jungle canopy either hunting or feasting upon prey. You may want to keep your leopard character's clothes to a minimum, allowing a greater range of movement and preventing embarrassing snags on branches. Bulkier than cheetahs but not as big as tigers, leopards are in the middle size range for the big cats. They weigh only 60 to 65 pounds (30 to 70 kilograms) so you will want to keep these characters lean with not a lot of extra muscle mass. Leopards are strong, elegant cats. This character's fur, like the fur of most leopards, is covered with spots called rosettes.

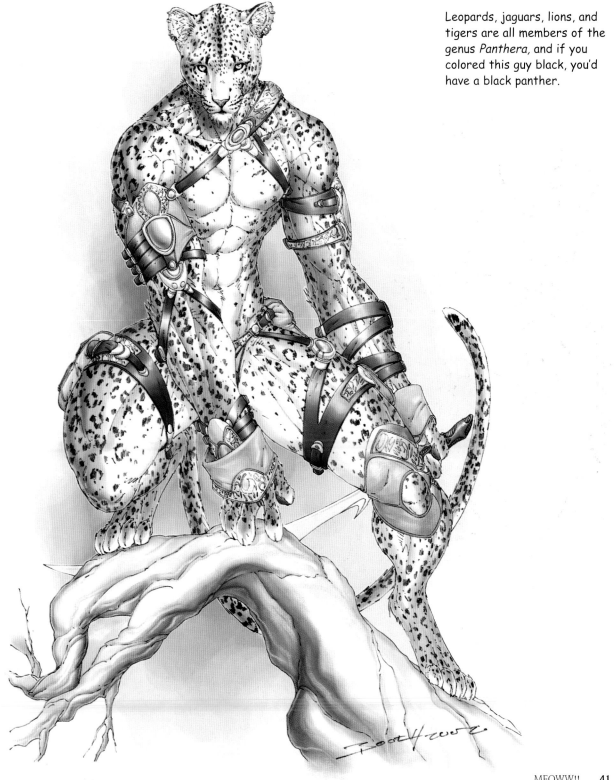

Leopards, jaguars, lions, and tigers are all members of the genus *Panthera,* and if you colored this guy black, you'd have a black panther.

Start with a pose that expresses your character's personality. This leopardess isn't yet coiled to spring, but she's ready for anything.

Her shoulders are narrow, but there's a world of strength in those powerful legs. This drawing looks complex, but it is really just a combination of different geometric shapes. From paws to thighs, for example, we have half cylinder, cross section; cylinder; circle; upside-down bowling pins; for "knee" joints, circles and ovals.

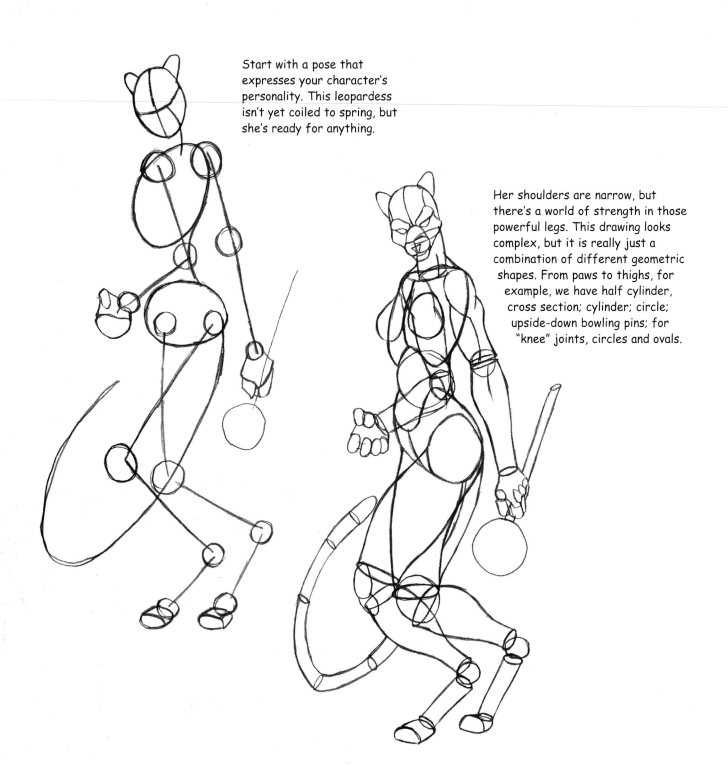

All the details are in, including some cool pieces of armor and a mace with the feminine touch. And check out that thong bikini! This character is a formidable scrapper armed or even empty-handed with only her claws and wits to see her through. This pose does an excellent job of conveying many different traits of the character in a single image. At a glance you see she is intelligent, alluring, confident, and agile: as interesting internally as she is externally. Complex characters make for interesting subject matter for both the artist and the viewer. Try to breathe as much life as you can into each illustration you create.

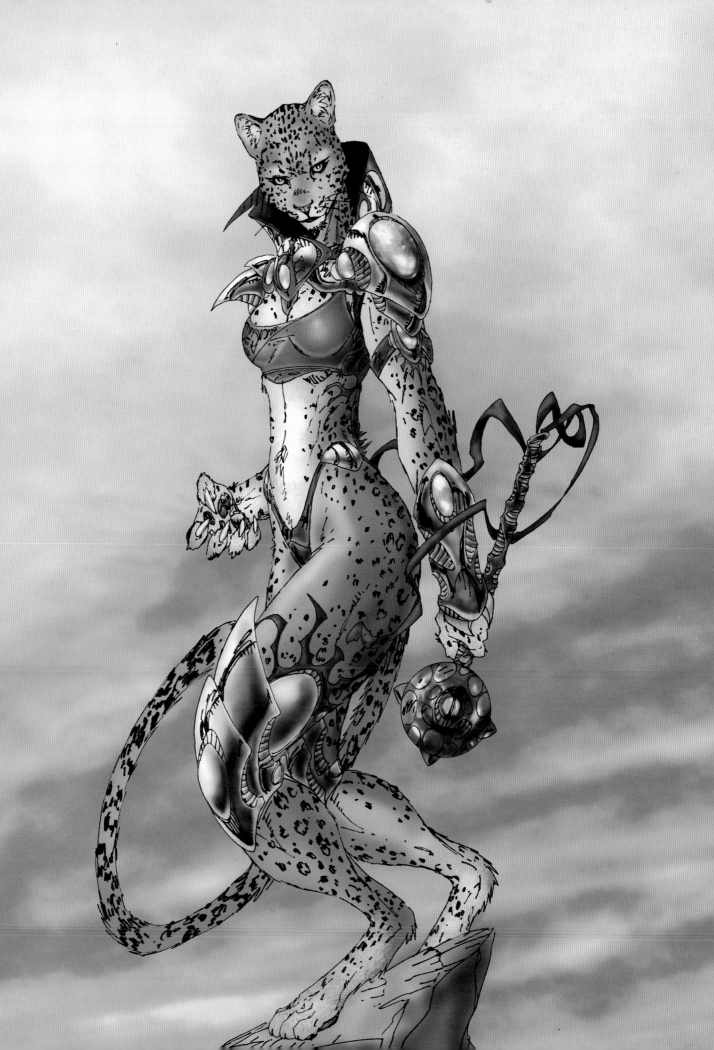

The King of the Jungle

Like all of the big cats, lions are fierce predators. Unlike tigers and panthers, however, lions are extremely social animals. They live and hunt together in a sort of extended family group called a pride, which consists of one to three males, up to seven related females, and fourteen to fifteen cubs.

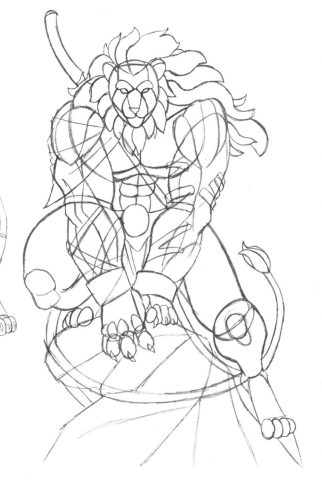

When sketching out the pose for your king of the jungle, make sure it conveys a sense of massive nobility. The shoulders should be wide and the stance proud and sure. A male lion's mane is one of his most captivating features. Draw it lush and full, and completely encircling his head. Lions have extremely powerful hind limbs, and their paws are huge. Sideburns never go out of style for this guy!

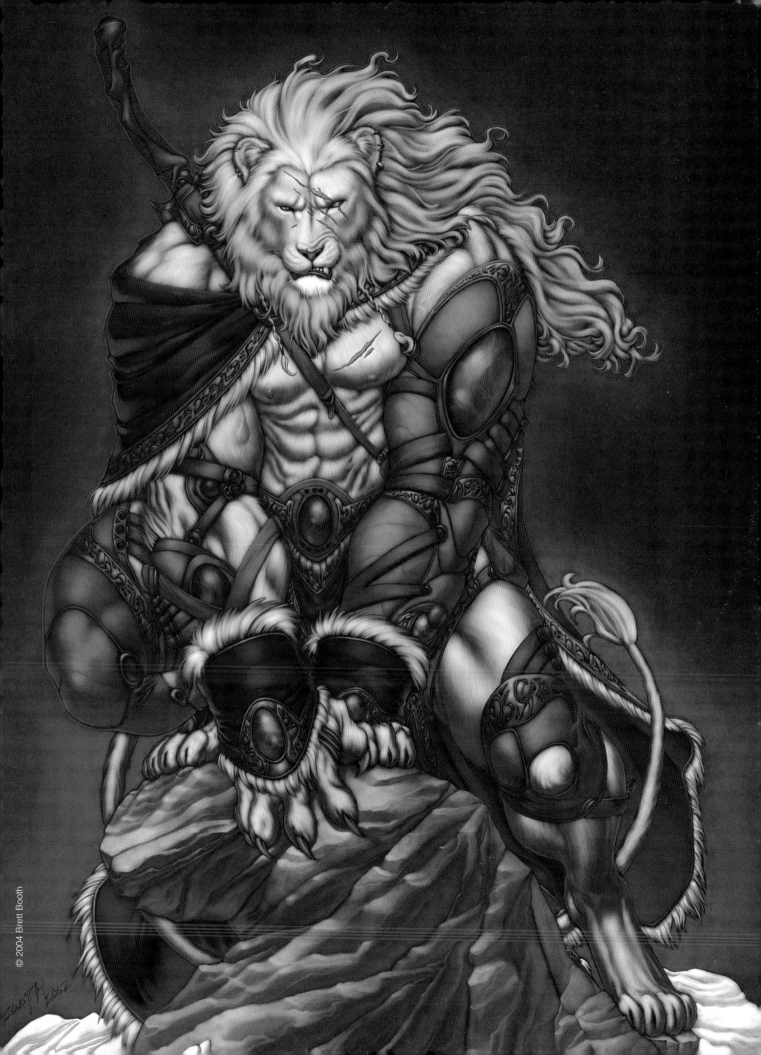

Lioness: The Hunter

Where would the king of the jungle be without his queen? Despite their imposing appearance, male lions are lousy hunters, and lionesses do up to 90 percent of a pride's hunting. It is only logical then to incorporate all the traits of a skilled hunter into your lioness design.

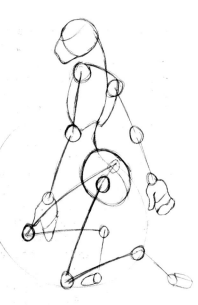

A classic personality test question is, "If you had a tail, what kind would it be?" The answer is supposed to reveal just what type of person you truly are. Even in this initial drawing, notice how dominant the tail is in the design.

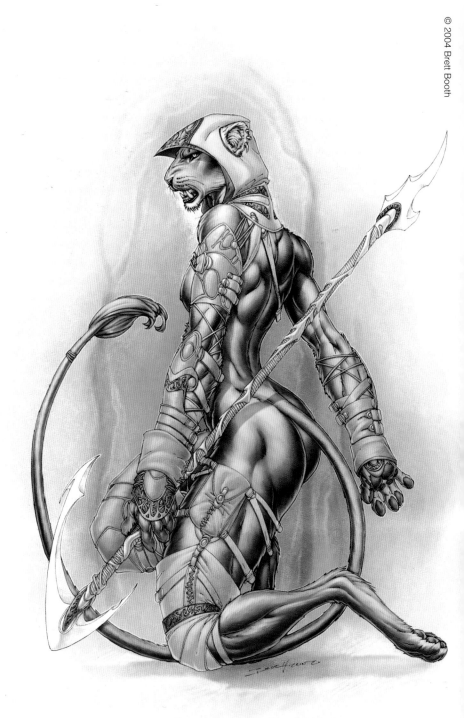

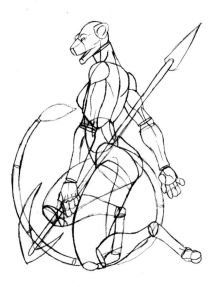

All the geometric shapes are in. The powerful tail and the two-headed weapon work in dynamic harmony to guide the viewer's eye.

Everything here—from the mighty hind paws to the exaggerated musculature to the details of the armor—works. There can be no doubt that this mighty warrior could hunt down just about anything.

Meanwhile, Far from the Jungle

Maybe you don't want to create a big-cat character.
There are lots of other fabulous feline possibilities.

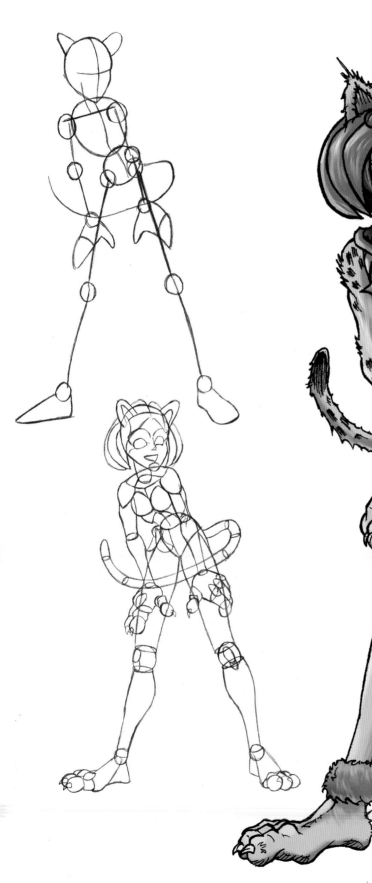

Cutey Kitty is drawn in a manga-inspired style. Like most manga characters, she is obviously a teenager. Her limbs are thin, her waist and pelvis are narrow, and her face is unlined. Youthful characters have a zest for life that should radiate from the page. You can tell from her expression and posture that she is an energetic and happy-go-lucky kitty, the kind of girl all the manga boys would love to get their paws on. Try to choose poses full of pep that reflect your character's inner being. Stay away from lifeless, static poses. Imagine you have a camera and you want to catch your subject at the peak of action. It may take several tries, but keep practicing until you get it purr-fect.

DOG PEOPLE
From Fierce Hunters to Foxy Lady

The dog family, Canidae, includes all of our trusty canine companions. What you may not know is that foxes and fennecs are also canines. So, for that matter, are wolves, but man-wolf transformations loom so large in myth and legend that werewolves have a chapter all their own.

Despite all those garage sale black velvet paintings that show dogs playing cards, dogs would make lousy poker players. It is extremely difficult for a dog to practice the art of deceit. Every emotion is immediately telegraphed from the brain to the tail. Wouldn't life be easier if we could spontaneously read our friends, family, and coworkers as easily as we can a canine? But dogs are not valued only for their honest, straightforward approach to life and relationships. They are also fast, strong, intelligent, and overflowing with will power. For all these reasons, dog-human hybrids make fantastic characters. When you start out to draw your dog person, remember that you have to go beyond general canine physical characteristics. You need to go deeper and capture the personality of the breed as well.

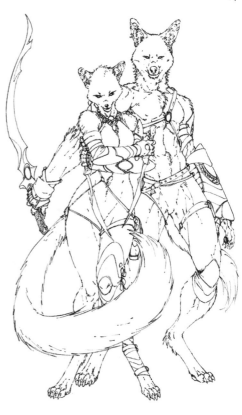

I don't think Jimi Hendrix was quite thinking of this lady when he penned his famous song "Foxy Lady," but I can't think of anyone it more aptly applies too. It goes without saying this fox is a head turner.

Canine Hunters

Never forget that that the cuddly dog who sleeps curled up at the end of your bed is first and foremost a carnivore, descended from fierce, efficient hunters who were able to pursue their prey over long distances.

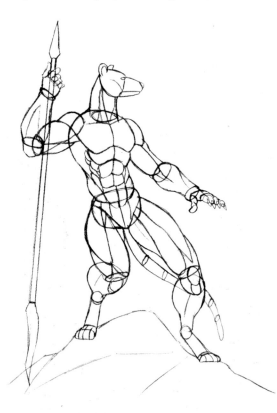

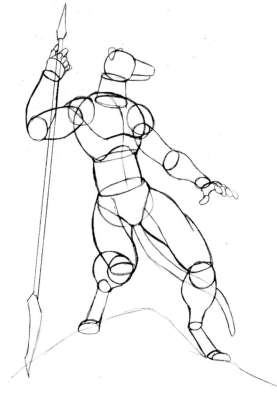

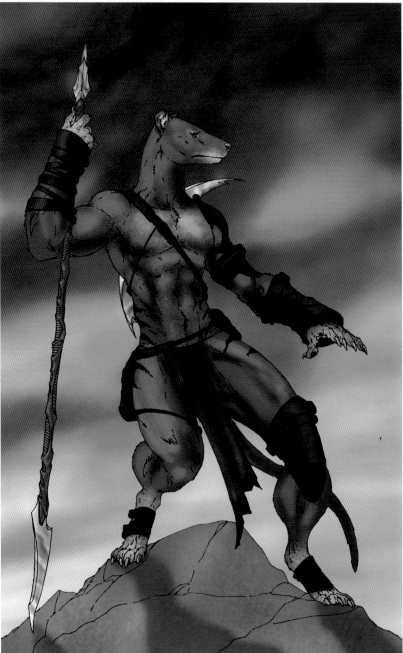

The Thylacine—aka the Tasmanian pouched wolf aka the Tasmanian Tiger—was actually not a dog (or a wolf or a tiger) but a doglike marsupial, and the last one was probably killed in Australia in the early 1930s. They were relentless predators and usually killed their prey by crushing the victim's skull. Remember: Your personal gallery of fantastic creatures is limited only by your imagination. Try turning back the clock to explore some of the wonderful animals that have gone extinct. You're already breaking the laws of nature, so why not disrupt the time-flow continuum and break the laws of physics as well?

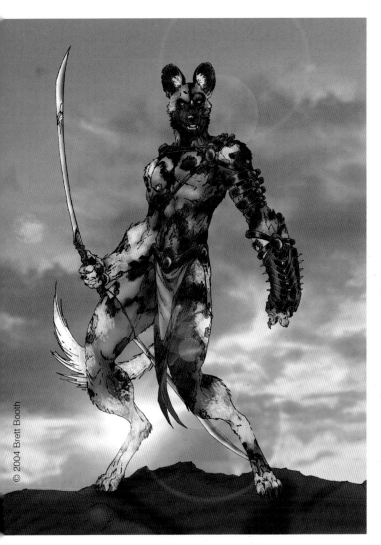

African Wild Dog

There's no mistaking the ancestry of African wild dogs, which hunt and thrive in a part of the world where they have to compete for food against the likes of lions, leopards, cheetahs, and hyenas.

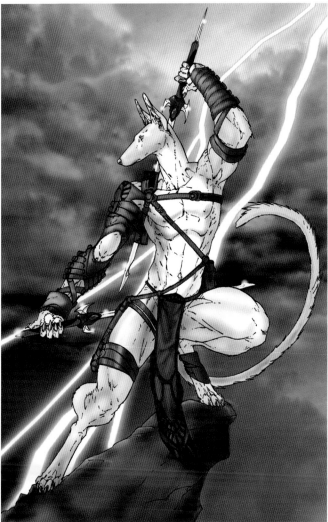

© 2004 Brett Booth

© 2004 Brett Booth

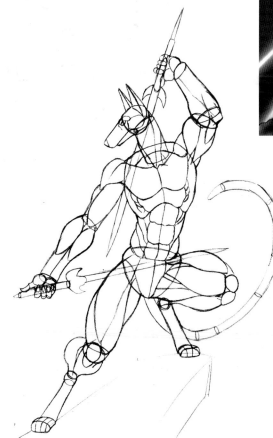

The Ibizan Hound

Ibizans are graceful, highly athletic dogs, known for their agility and speed. Remember that one of the key abilities of a fighter is dexterity; it is not all about brute force. This guy has a strong, confident grace about him. He may have the nimbleness of a ballerina, but I don't think you will ever catch him wearing a tutu.

Greyhounds

When you hear the word "greyhound" you immediately think, "fast." They are in fact the fastest breed of all dogs. Greyhounds were initially bred as hunting dogs that would be able to outrun their prey. Greyhounds can reach a top speed of 45 miles per hour, and can maintain speeds of over 30 miles per hour for up to a mile. Their incredible speed led to their popularity at dog tracks and it is no accident that the logo and name for the largest North American bus line is Greyhound.

When drawing characters based on greyhounds you will want to endow them with a broad, muscled chest and a narrow waist, so start out with the right relative proportions.

Build up your long, lean matchstick limbs, but be sure not to make them too thick.

Greyhounds are all highly defined muscle with very little body fat. The forehead and the bridge of the nose are almost indistinguishable from each other.

Remember to think through your character's personality as well as its physical appearance. Greyhounds are highly intelligent animals, often needing not only to outpace their prey, but to outthink them as well. They are masters at predicting a prey's next evasive action and acting on the fly to calculate an interception. This guy looks ready for anything.

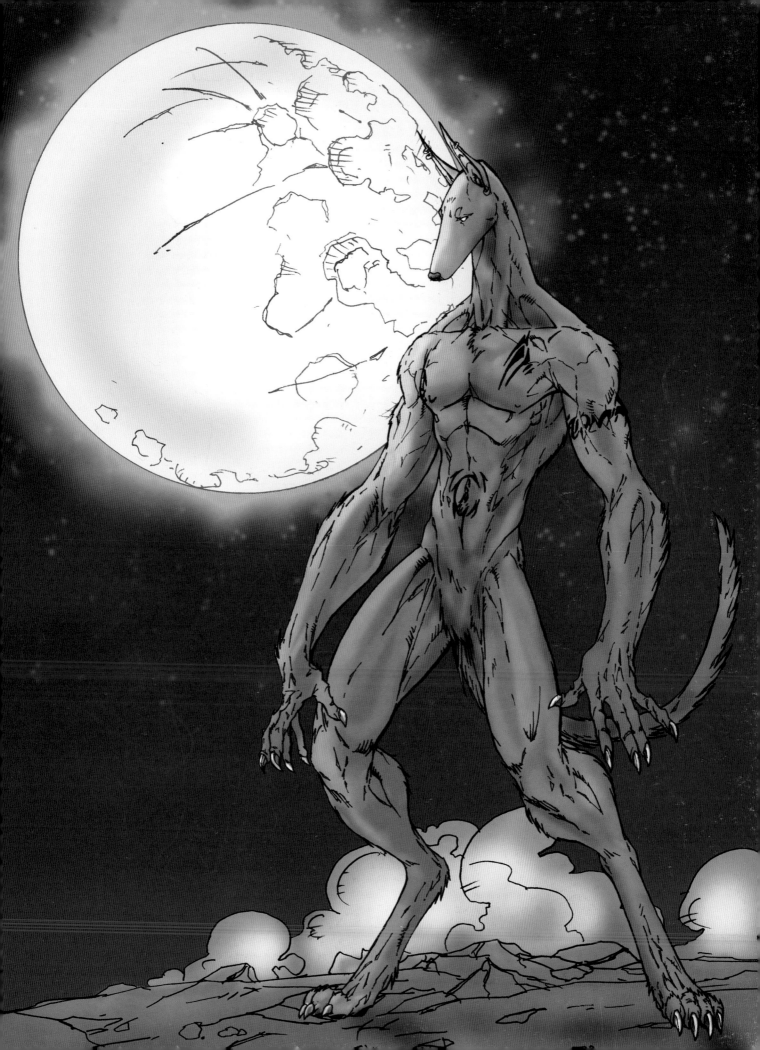

Domestic Dogs

"Noble," "loving," "courageous," "loyal"—these are just some of the qualities that have earned domestic dogs the right to be called "Man's Best Friend." Who can resist a canine with a big, toothy smile and a joyfully wagging tail? Dogs have so many of the characteristics we long to see in our fellow human beings that it is no wonder many people prefer a dog's companionship to human company.

Bulldogs

Bulldogs came by their name honestly: They were bred to fight bulls in the arena. You can't get much tougher than that. The bulldog's thick, massive head sits atop a compact, highly muscled body. They are the Sherman tanks of the canine community. This stocky breed is often characterized as being not only a powerhouse of strength, but also an extremely playful animal, full of mischief. Remember that kid who always sat in the back of the room and made gross body noises to crack the class up? Then you should have a good start on developing the personality of your bulldog character.

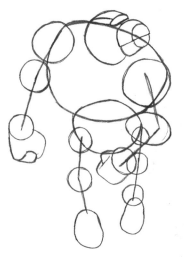 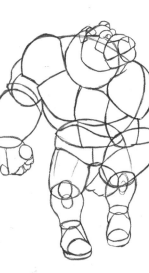

The key to drawing your bulldog is to remember that all the vigor and brawn of a body builder have to be squeezed into a smallish frame. Exaggerate the width of the head and sit it almost directly on the shoulders. Bulldogs are stout and should have a real sense of mass and weight no matter what position you put them in. Exaggerate the size of the circles where the joints are. This will help you better visualize the mass of the limbs before moving on to the second step.

Just because this guy is built like a bulldozer doesn't mean you have to draw in definition lines for every muscle. The exaggerated size of the forms conveys this information. Slightly hunch the character's back as if his top-heavy frame is curved under all the extra weight of his muscle-bound neck and head.

You get the feeling that this guy is tough, but he probably has a layer of fat from kicking back with the boys at the local watering hole after a hard day of busting heads. He's probably adept at playing the big, dumb, lovable jock—one the sweet female bulldogs would just love to take care of.

Artist: Mitch Byrd

Mutts

Maybe you don't *want* to draw a noble purebred. The great thing about mutts is you can mix and match the characteristics of your choice and put them all into one character. You want the body of a chihuahua and the head of pit bull? Go right ahead, but don't ask for my help in housebreaking him.

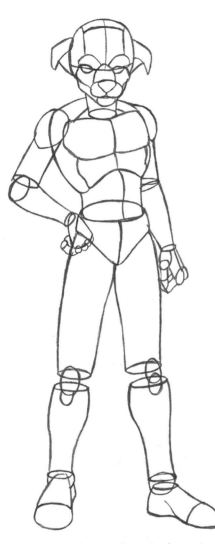

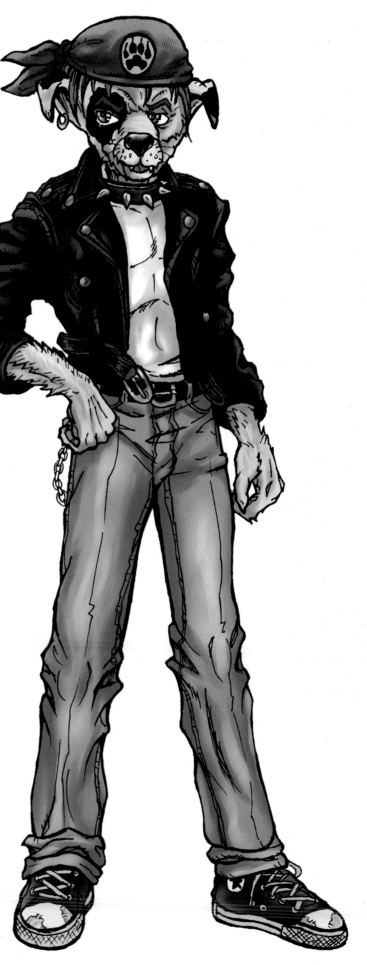

Punk Mutt here is drawn in a slightly more cartoonish style, which can be just right when you are drawing a character-driven story or if you want to explore sensitive social issues without upsetting or alienating any particular group of dog owners.

Foxes

If you look at how "fox" is used in the English language, you might think foxes have gotten a bad rap. It's no compliment to say that someone is "sly" as a fox, and the metaphor "it would be like letting a fox loose in a henhouse" is used to describe something that you would do only if you didn't mind extreme carnage. Fox is also used as a synonym for cheats, tricksters, and con men.

What we should really look at is the fox's positive ability to adapt. Few animals are as resourceful as the fox. Though hunted and trapped throughout the centuries the fox continues to survive and thrive, both in the wild and in towns and even cities. The truth is we are probably just sore losers, having been consistently outfoxed by these ingenious little fur balls.

Characters based on the male fox should be filled to the brim with charisma. Foxes are famous for being cunning, but that does little good if they can't get anyone to trust them. Are his motives pure? Or is he a manipulative scoundrel? He may be a cocky, flamboyant, headstrong braggart, or he may be a sneak, making all his moves under the cover of darkness. Regardless, men will want to be like him, and ladies will swoon to be near him. Personality helps a character go a long way.

A male fox is called a reynard, the female is called a vixen. Reynard here may be much bigger than his vixen friend, but she's got it all over him in the tail department.

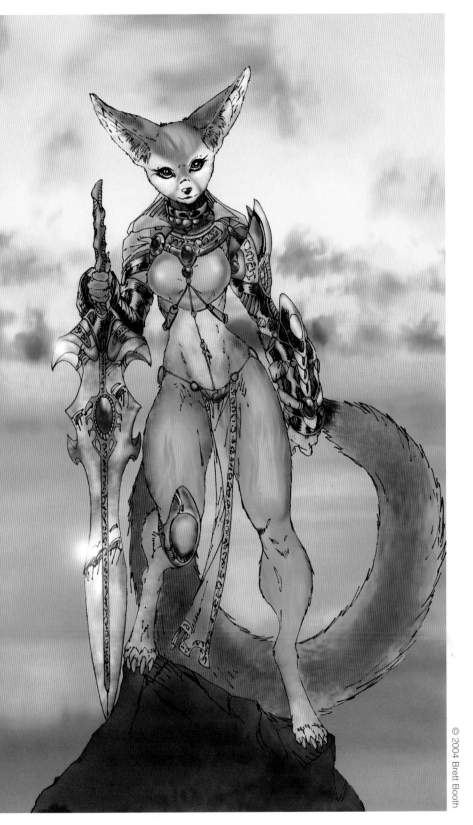

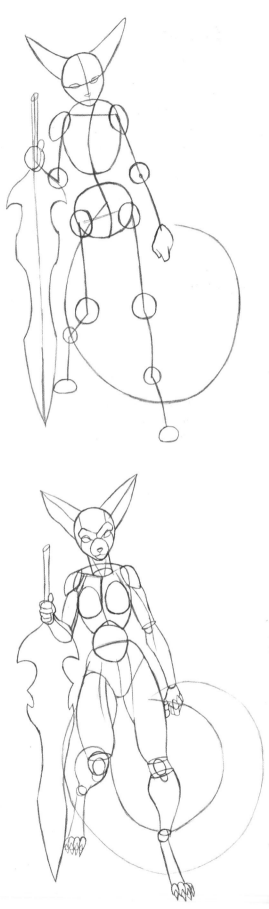

The fennec fox is the smallest of all canines. Their enormous ears are so sensitive to sound that the fennec can actually hear an insect walking across the desert sands, but they do make it hard to shop for a hat. They also have extremely large eyes to aid them with their nocturnal hunting. Fennecs are amazing leapers and can bound straight up two to four times their own height. Fennecs are especially adept at surviving in hot climates.

SIDEKICKS

Sidekicks. A lot of super good guys (and super bad guys) wouldn't be caught dead without one. When toppling evil masterminds bent on world domination, two heads are definitely better than one. Besides, it's nice to always to have someone within earshot when you come up with an especially snappy one-liner.

Most sidekicks are the smaller member of the duo, and are likely to be eternally youthful and exhuberant. A sidekick can help add an element of light-hearted humor to otherwise dark tales. They usually embody the heart and soul of a team by maintaining an optimistic sense of wide-eyed wonderment. Sidekicks are a staple of fantasy story telling. Often overworked and underappreciated, sidekicks can fulfill a number of different roles. They may be portrayed as helpers, apprentices, comic foils, annoying hangers-on, or any combination of these. They can also bring some totally new skill to a team, or play an integral role in broadening the appeal of a particular character or story line. When designing your sidekick characters, you definitely don't have to stick with the more imposing members of the animal kingdom.

Squirrel Girl
Squirrels, like hamsters, are rodents, and there are over 250 species of those little rats with bushy tails. Squirrel sizes, from nose to end of tail, range from about 9 inches (the Indian striped squirrel) to 2 feet (the giant red flying squirrel—how about *that* for a great sidekick), and the variety of squirrel coats rivals that of the cat family. Squirrel Girl here is based on a college friend of mine. I just thought of her cheerful and chatty personality and the character practically drew herself.

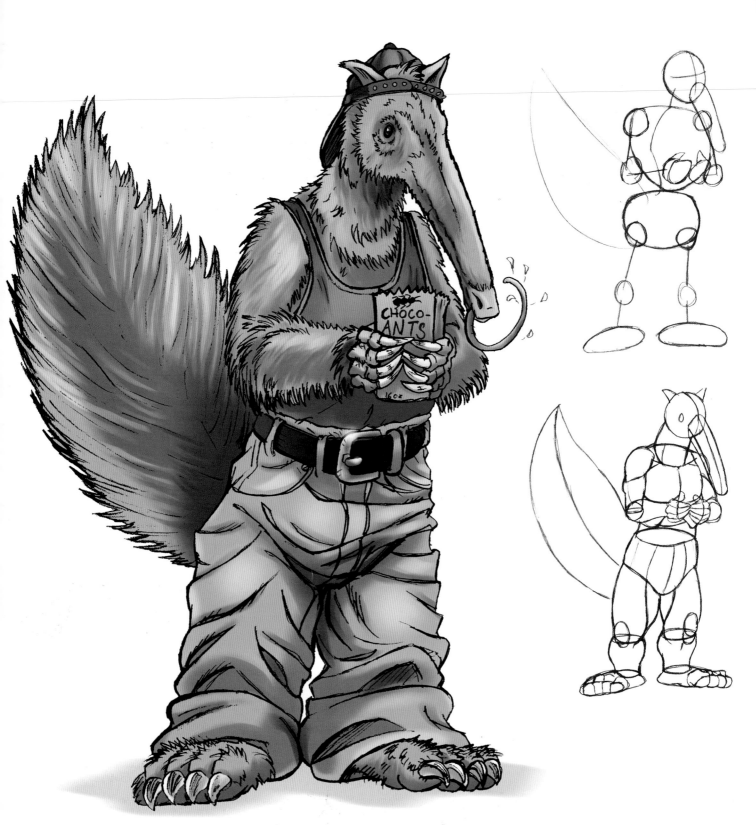

I Was a Teenage Anteater

Designing younger characters opens up the possibility of telling compelling stories of teenage angst and the difficulties associated with those painful young adult years. Consider the audience you are trying to appeal to and age your characters accordingly. But remember: The first rule of crafting a story is to write about what you know. Very few of us have the right life experience to tell a convincing tale about a geezer edenta (meaning "having few or no teeth," e.g., anteaters and sloths), but we all know what it's like to be a teenager.

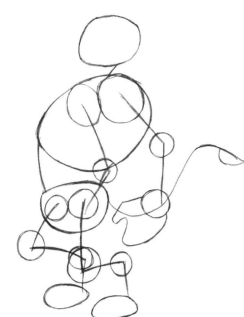

Mini Lion:
Half the Size, Twice the Fun
He may only be three feet tall, but his roar is mighty! What this lion lacks in height he makes up for with his abundance of personality. Don't short-change this cat in the attitude department; this type of character is always out to prove himself and earn the respect of others. This keeps him in the center of the action and there is no place he'd rather be.

Supermole

One humorous device often used in comic book storytelling is to take all the powers of a well-known hero and grant them to an animal sidekick character. Sometimes these characters prove popular enough to sustain their own ongoing comic book or cartoon series. It is a way for artists, writers, and fans alike to step back and make a few good-natured jokes parodying some of the sillier and more self-important aspects of the comic book genre:

Faster than a self-propelled lawnmower, more powerful than a ditch digger, able to burrow under a tall building with a single tunnel . . . Look down at the ground! It's a groundhog! It's a faulty sewer line! No. It's Supermole! Yes, Supermole, strange visitor from a subterranean world. Defender of Truth, Justice, and the Insectivora Way.

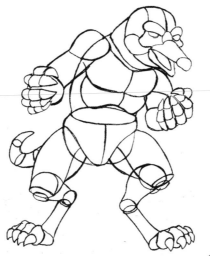

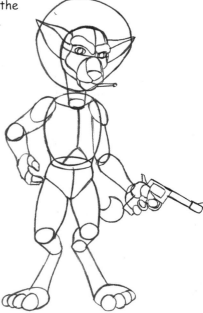

The Chihuahua Bandit

Part of the fun of drawing animal characters is you can get away with some pretty silly stuff. You want to draw an adaptation of the movie *The Good, The Bad, and The Ugly* with a Chihuahua in Eli Wallach's role? Maybe he is the leader of the infamous Bean Burrito Posse, a group of Chihuahuas gone bad who ride across the land holding up Taco Bells. Anything goes.

Artist: Steve Hamaker

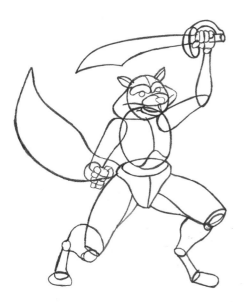

Swashbucklin' Raccoon
Anyone who has ever gone camping has probably run into one of nature's bandits, the raccoon (no wonder they wear masks). It seemed only fitting to cast this masked bandit as a pirate in an anthropomorphic adventure on the high seas.

Sydney the Rock 'Em Sock 'Em Roo
The gloves may be on Syd's paws, but his feet are what you have to watch out for. After running you down at a cruising speed of 20 miles per hour, he could have you pushing up daisies with one powerful double-footed kick.

Ratilla the Hun

This guy is a dirty rotten lowlife rat, which is a good thing. Great heroes need great villains. You don't want to make a story's conflict resolution appear too easy for your characters. You want to test them and push them to their limits and then push them some more. Nobody wants to watch a do-gooder effortlessly mop the floor with his adversary. A good story will constantly have an undercurrent of tension, leaving the viewer wondering if the hero will succeed or fail. I first conceived of Ratilla as a half-size sidekick, but once I got into the drawing decided that this guy is probably the big cheese, the lead bad guy, who won't be revealed until the plot's climax after all his rodent underlings have been killed off and our hero and Ratilla go mano a mano.

Hamster Grrl

The undomesticated golden hamster, which hails from the Middle East, is a solitary, aggressive animal, and this chick certainly seems to be going back to her roots. From her clothes to her posture she is saying, "I'm self-assured, I can take care of myself, and I don't take flak from anyone." Today's heroines, like Hamster Grrl (and that's not a typo), are strong and resourceful. But if you look at her eyes, you can see that buried beneath her rough, tomboyish exterior are some vulnerable areas.

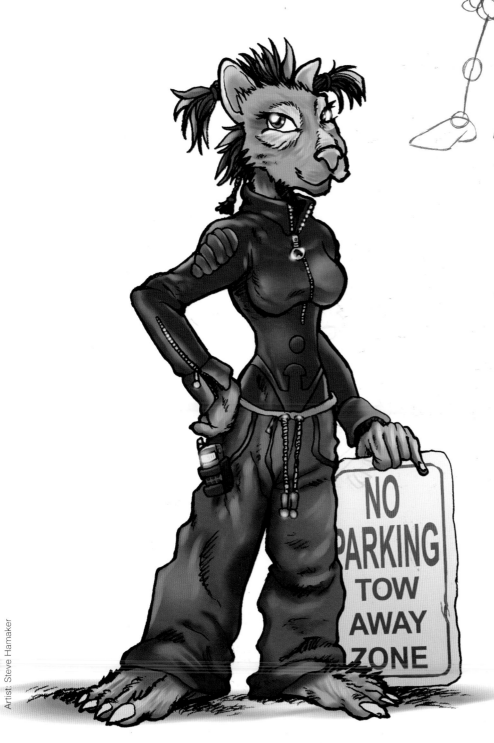

CREATURES WHOSE BLOOD RUNS COLD

Actually, the blood of any one of the so-called cold-blooded creatures is not always cold, but is completely dependent on the surrounding temperature. (The blood of a coiled rattlesnake that has been lying in the sun for a long time is most definitely not cold.) Mammals can regulate the temperature of their blood. Reptiles, amphibians, and most fish cannot. So why does the sight of so many creatures whose blood "runs cold" freak a lot of people out? Maybe it's the images of their nasty eating habits (from pythons swallowing pigs to the creepy-crawly diet of frogs and toads). Maybe it all started with the dinosaurs.

Real basilisk lizards are members of the iguana family, but in Greek mythology, basilisks (aka cocktrices) were fearsome creatures with the wings of a fowl, the tail of a dragon, and the head of a cock—and it was certain death to look one in the eye. In Shakespeare's *Richard III* when Richard compliments Lady Anne on her eyes, she replies, "Would they were basilisk's, to strike thee dead." I don't know whether basilisk lady here could murder with a glance, but she is certainly a formidable opponent. Basilisks are able to run in a semi-upright position, using their tails as balance. When I drew her, I wanted to convey that whatever—or whoever—transformed her into a monster wasn't doing her any favors. The change for women can be emotionally crippling, often pushing them over the edge of depression into . . . into . . . what else but a life of crime.

▶ Dinosaurs were agile hunters. Drawing your dino people in dynamic action poses will help eradicate any lingering notions that they were ungraceful and clumsy. As you look at the creatures on the next few pages, notice how varying just a few physical attributes produces a competely different look.

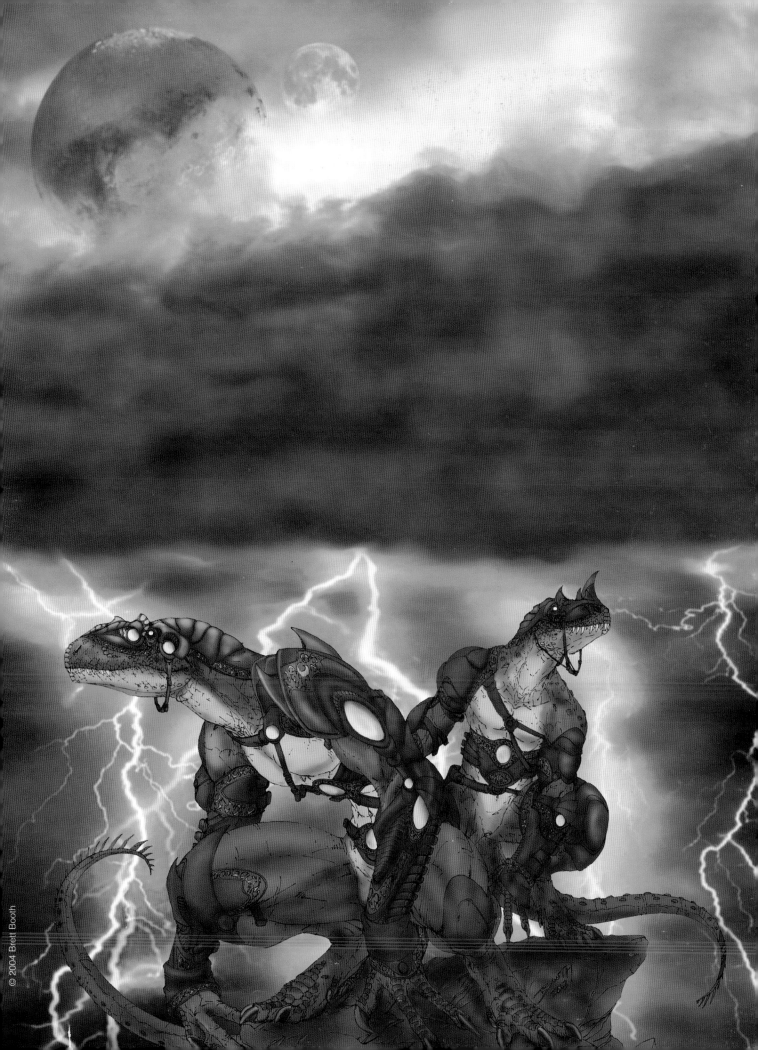

Dinosaurs and Crocodilians

Dinosaurs may be extinct from the face of the planet, but they are alive and well in our imaginations. They have always been of special interest to kids, and after Spielberg's 1993 *Jurassic Park* hit the screens with its state-of-the-art special effects, dinosaurs have been experiencing a resurgence in popularity. It was inevitable that sooner or later someone would combine these "terrible lizards" with human DNA to make fearsome reptilian warriors.

There is an almost inexhaustible number of dinosaur ideas to play around with. See how many "new recipes" you can come up with. Check out dinosauricon.com. It has hundreds of dinosaur drawings, as well as 2D and 3D digital images, from artists all over the world and invites visitors to the site to submit drawings.

You will want to use all of dinosaurs' most monstrous attributes as ingredients in your recipes. First off, the head is large compared to the rest of the body, I guess because dinosaurs need somewhere to store all those dagger-like teeth. Next, the body is a stocky mass of muscles contained in a thick reptilian hide. Add one formidable tail; remember it is not only there to provide a counterbalance but can also be used to bash enemies flat. Are we forgetting anything? Oh yes, no self-respecting mutanosaur would be caught dead without a set of elongated razor-sharp claws. That should do it. All the terror of a 5-ton monster now available in a convenient human-sized package.

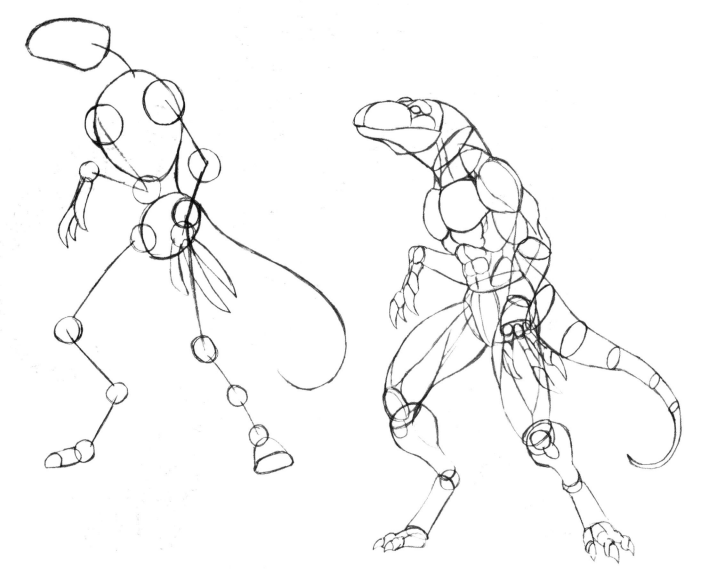

Acrocanthrosaurus
The proportions here—from the giant head to the massive thighs—reflect the fact that Acrocanthrosaurus means "high-spined lizard." You've got to agree that this Acroc would be a fearsome adversary.

© 2004 Brett Booth

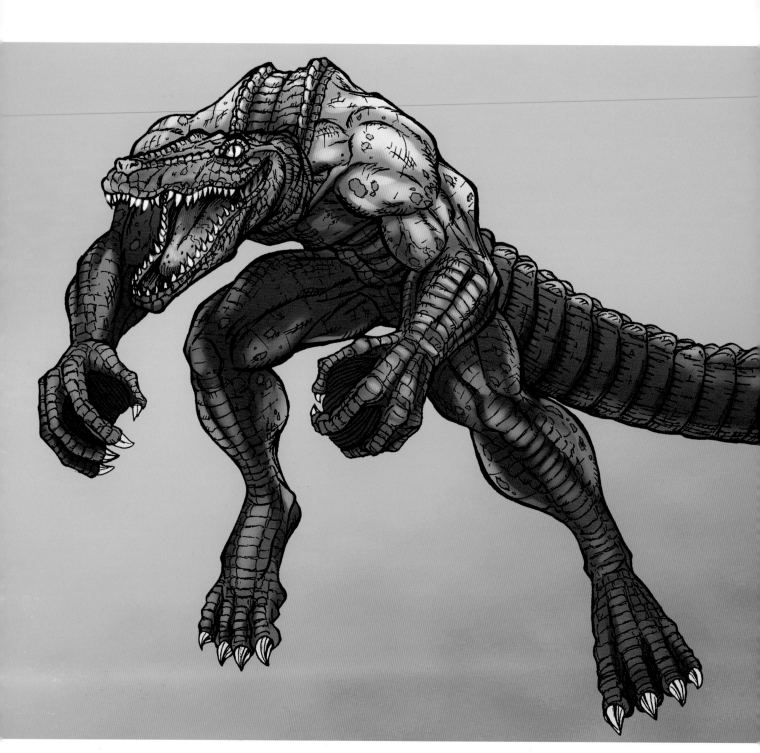

With their toothy smiles and plated hides alligators are a living link to the age of dinosaurs. This guy is a little more lethal than your garden-variety belly crawling gator. Was this abomination once a man? And if so, how much of his sanity survives? One of the great story elements for mutant characters is the internal struggle to maintain a sense of humanity once a character's outward appearance has been radically changed: the fight between what he was and what he has now become. Which side will prevail? I don't know, but I'm not going to stay anywhere near this guy to find out!

This dinosaur has a broader chest, a longer and thicker neck, and much larger arms than the character on the previous page.

Frogs

Frogs are amphibians, a group that also includes toads, newts, and a weird legless type called caecilians. They are cold-blooded animals that live part of their lives on land and part of their lives in water. Frogs have long, flexible, sticky tongues, which they can whip out with lightning speed to capture their prey, which they then swallow whole. Some frogs even secrete a poisonous toxin that deters would-be predators. Add the fact that frogs are super-good swimmers and you have the makings of an extremely interesting character.

Most amphibians, and certainly froggy here, "breathe" through their skins, which need to be kept moist, so you will want to give your frog characters a minimum of clothing. Obviously the physical trait frogs are best known for is their leaping ability. Frog characters should have long, powerful legs to propel them forward. I'm not sure what I had in mind when I drew what looks like a scepter in froggy's right hand. Perhaps it has magical powers, perhaps not, but it leaves no doubt that this frog is king of the pond.

Not all frogs spend their lives sitting on lily pads hoping to snag unwary insects. There are at least 300 species of tree frog, and they come in a remarkable variety of colors, from gray to bright green to bright orange. One especially cool-looking guy is called the northern red-eyed tree frog. They all have in common suction pads on each digit, which allows them to climb up even smooth-barked trees with ease. I have taken a few liberties with this frog's anatomy by making his "arms" super long, but hey, it's my imagination! If you need some inspiration, just type in "tree frog" in the Google search line. You'll be amazed at how many great color shots you'll find.

Lizards

Iguanas, chameleons, geckos, and agamids are all lizards. Most lizards could be described as creepy-crawly. The agamids—among which are the flying dragon, the thorny devil, and the frilled lizard—are probably the weirdest of the lot, although there are a few species of really nasty legless lizards that look like a cross between a worm and a snake. Ugh.

 Chameleons, with their large neck crests and protruding horns, appear to be descended from dragons. There are several different types of chameleon, but they share some common traits that set them apart from the rest of the animal kingdom. The characteristic they are best known for is the ability to change color according to the background color of whatever they are sitting or climbing on.

Chameleons have eyes like turrets, allowing each eye to rotate 180 degrees independently, and prehensile tails that coil around branches while they navigate the treetops, and I put those features in the first sketch.

This chameleon has obviously just been somewhere green. Although his tongue isn't out now, all chameleons have long, sticky tongues that whip in and out of their mouths like bungee cords when capturing prey. Or if you happen to be a mutated 6-foot-tall reptile with that kind of tongue, you could probably use it to grab snacks out of the kitchen without leaving the comfort of your chair. Of course, you might decide to go on the road and snatch passing purses instead.

There are over 675 species of gecko and, like tree frogs, they come in some really wild color combinations, like the Tokay gecko, who has what looks to be a plaid body and spotty head; the leopard gecko, who actually looks more like a tiny, slimy spotted alligator; and the *Phelsuma vinsoni,* who is chartreuse, hot pink, tourquoise, silver, and green! In many cultures geckos are believed to bring good luck. That seems right. I imagine you would want luck to be on your side if you spent a considerable amount of your day walking upside down from heights that could kill you.

I decided early on to draw one of gecko dude's feet facing up, so you'd be able to see the sticky, hair-colored ridges on his foot. These are called lamellae, and they allow these acrobatic lizards to walk straight up—or down—walls and even stick to glass.

My early sketches for gecko dude, like the ones for the chameleon, were totally action-oriented.

Snakes

Is there any other creature as universally feared and hated as the snake?
Ever since the garden of Eden serpents have been associated with evil.

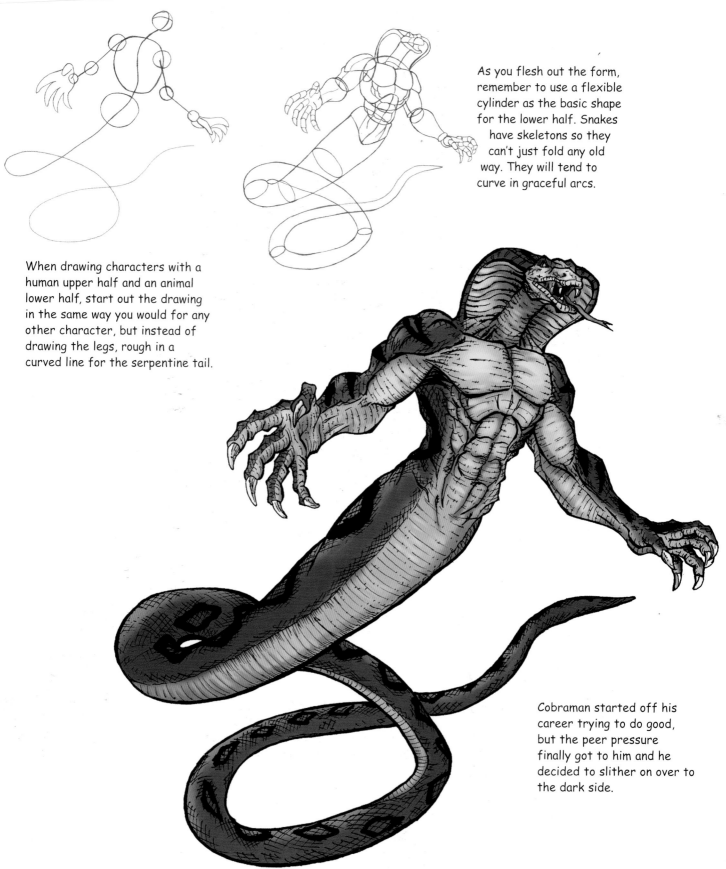

As you flesh out the form,
remember to use a flexible
cylinder as the basic shape
for the lower half. Snakes
have skeletons so they
can't just fold any old
way. They will tend to
curve in graceful arcs.

When drawing characters with a
human upper half and an animal
lower half, start out the drawing
in the same way you would for any
other character, but instead of
drawing the legs, rough in a
curved line for the serpentine tail.

Cobraman started off his
career trying to do good,
but the peer pressure
finally got to him and he
decided to slither on over to
the dark side.

Turtles

Ever since those four shell-kick'n kung fu dudes came on the scene this guy has had trouble finding work: no one wants to hire a turtle who can't do a spinning roundhouse kick. Oh well, he is only thirty and that isn't even a teenager yet in turtle years. He has a while before he has to figure out what he wants to do with the rest of his 200-year life. Regardless of what you see in cartoons, turtles are passive creatures for the most part. Instead of confrontation they would rather hide in their shell and wait until danger passes by. An exception to the norm is the alligator snapping turtle, which is known to take no flak from anyone but is more than willing to take a finger or two.

A turtle's shell has a bit of a lip to it. If you are having trouble getting the shape right try picturing it as a cereal bowl turned upside down on a plate.

THE BIG, THE BAD, AND THE UGLY

Every good team has one big lug to depend on for solid brute strength. Muscles, muscles, and more muscles are the key attributes for these guys (or gals). Although you're perfectly within your rights as an artist to put the temperament of a field mouse into the body of a hulking monster, a lot of the characters in this chapter have a hair-trigger temper. Almost all of them are bad, and most of them are also *very* big. Some, like Samurai Centaur and Monzilla Minotaur, have venerable ancestors. Others, like Elephantaur and Hogman, are total originals.

Centaurs have the legs and bodies of a horse, but in place of the horse's head they have the torso, head, and arms of a man. Anyone can draw that—or at least copy one of the many Greek pottery pieces that show centaurs. The challenge is to take a preconceived idea and make it your own. Why not a centaur samurai? Hey there is a reason they call it fantasy, which means anything goes. All genres are fair game and nothing is off limits. It is all about upping the coolness ante to create something different and new.

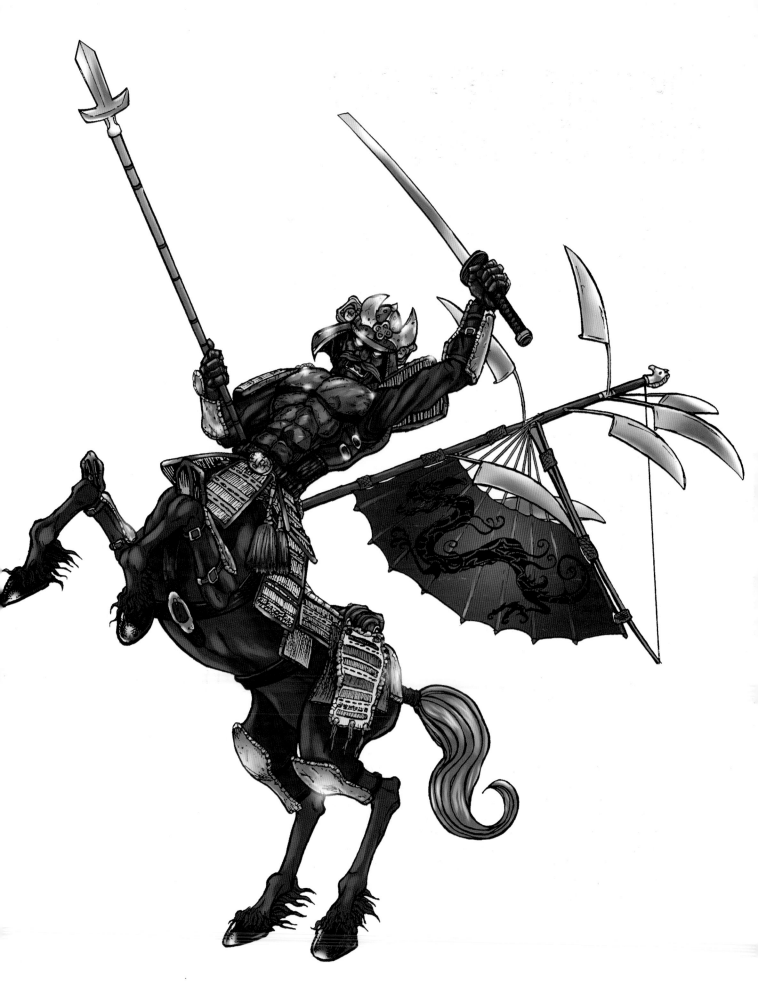

Pteroleo

Here we have the head of a lion, the leathery wings of some giant prehistoric bird, the talons of an eagle, and the tail of a dinosaur. Whatever he is, you sure wouldn't want to run into him while you were hang gliding.

Bison once roamed across every plain and prairie in America. Then foolish European settlers hunted them to near extinction. Now it's time for a little payback. Picking up the relics of the Indians his ancestor shared the countryside with, this burly buffalo is out to defend the rights of half-man, half-bovines everywhere. Of course if that doesn't pan out, he can always go back to helping his cousin, who owns a buffalo wing business.

Artist: Mitch Byrd

Pigs and Hippos

Although domesticated pigs are kind of cute, most wild pigs are *really* ugly. I've put Hogman in the same section as Ninja Hippo because boars and hippos belong to the same order of vegetarian mammals: Artiodactyla. They are also both highly aggressive.

What can I say, this guy is a real boar. Imagine the most nasty, distasteful, and obnoxious person you ever met. Now give that person tusks, a super-aggressive nature, and a fiery temper and you are beginning to understand what makes old Porky here tick. Boars go beyond just being rude; they incite hostility wherever they go. Boars do not turn the other cheek; not only do they never forgive but they escalate every confrontation into a major personal vendetta.

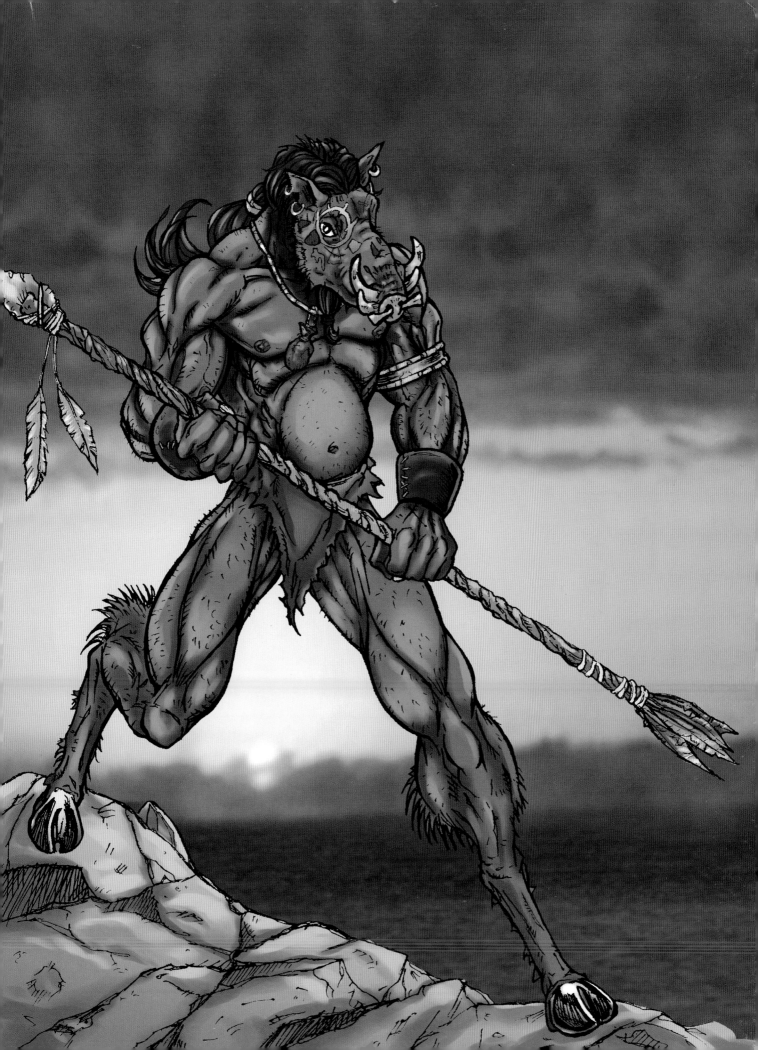

Ninja Hippo

Watching a hippopotamus grazing or wallowing in the mud, you might be fooled into thinking it is as docile as a cow, but venture too close and you will have over 4,000 pounds of angry hippo charging at you with its tusklike teeth ready to take a chunk out of your hide. Hippopotamuses injure more people annually than alligators or crocodiles.

Sometimes it is fun to design a character that is a visual paradox. You wouldn't believe a lady this big would be an agile assassin, but get on her hit list and that is likely to be your last mistake. If she misses with her wicked katana sword, she can always rely on her second-favorite mode of attack, a behemoth belly flop. She's also easy to draw.

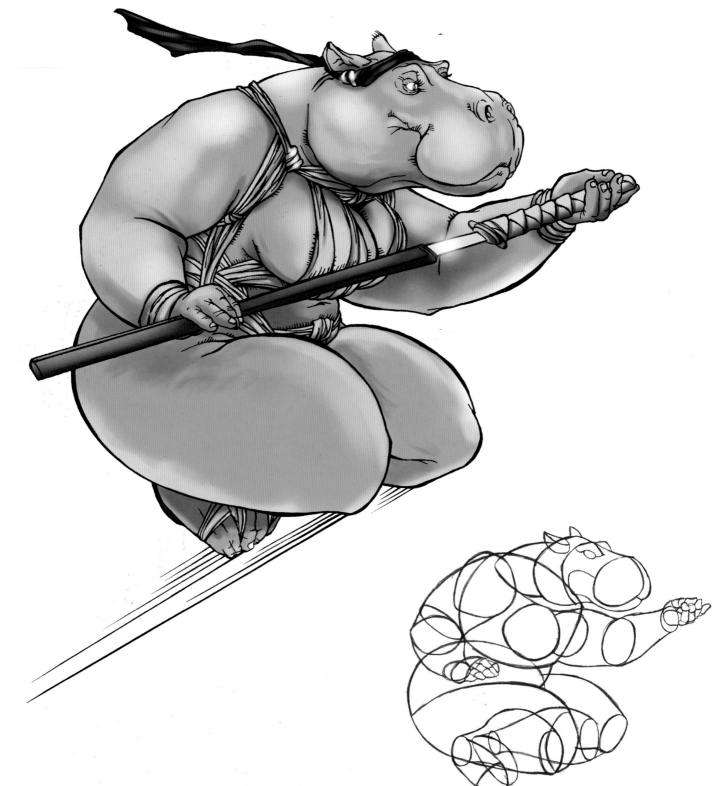

Artist: Mitch Byrd

Zebras

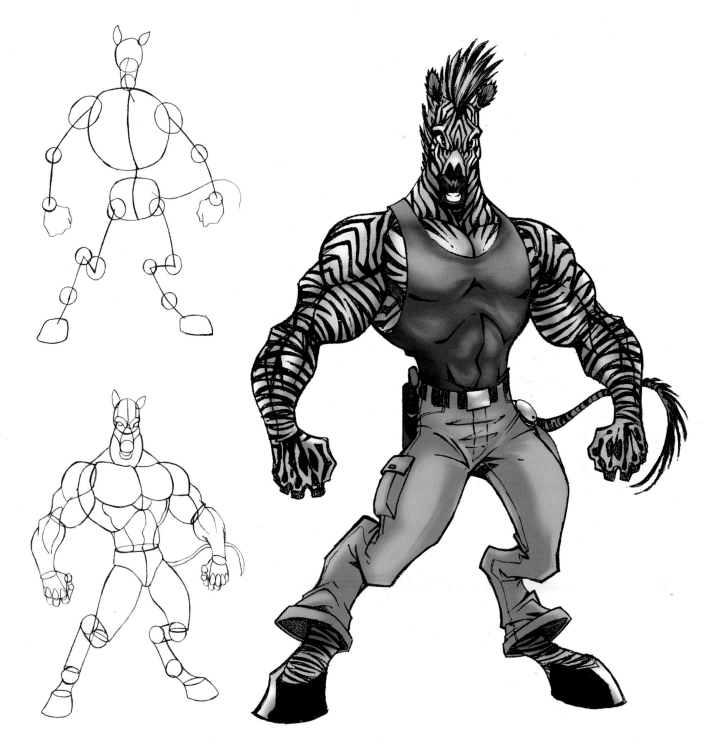

Zebraman

Zebras, like horses, are members of the genus *Equus*. They are white with black stripes, which may have evolved for purposes of camouflage, although this guy isn't about to hide from *anybody*. You could use this same basic design to create a horse person, but the stripes make Zebraman visually dynamic. Part of the challenge with fantasy art is doing something that has not been done before. Always look for ways you can put a new twist on an old idea to make your work original and stand out from the pack, or in this case stand out from the herd.

Modzilla Minotaur

The half-man, half-bull minotaur of Greek myth was kept by King Minos of Crete at the center of a maze where it devoured victims who couldn't find their way out of the labyrinth. It wasn't a half-bad gig until this guy named Theseus came along and, with the help of Minos's daughter Ariadne, killed the monster.

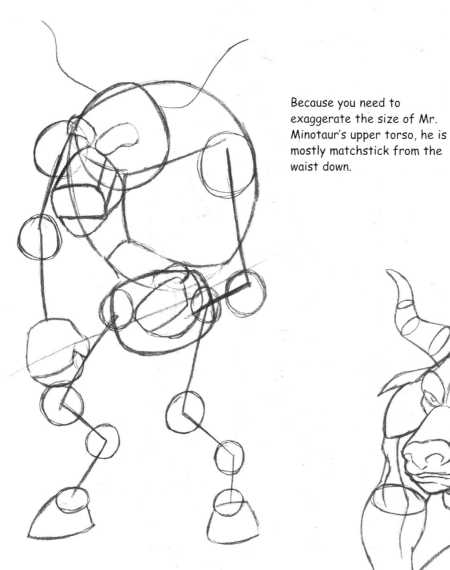

Because you need to exaggerate the size of Mr. Minotaur's upper torso, he is mostly matchstick from the waist down.

Hair will cover most of his body, but you will want to add some muscle definition, especially on the arms and chest.

Finish him off with a few spikes and a mean-looking ax. Now all you need is a maze for hours of monster-dodging fun.

Elephant Men

Some say that elephants, not lions, are the *real* kings of the jungle. If not kings then at least noble dukes. In reality, although the African elephant is the largest and most powerful of all living land mammals, it is also one of the gentlest. They are also highly intelligent. Besides man, elephants' natural enemies include lions, hyenas, and tigers, who are always on the look-out for juicy elephant babies to snatch from inattentive mothers.

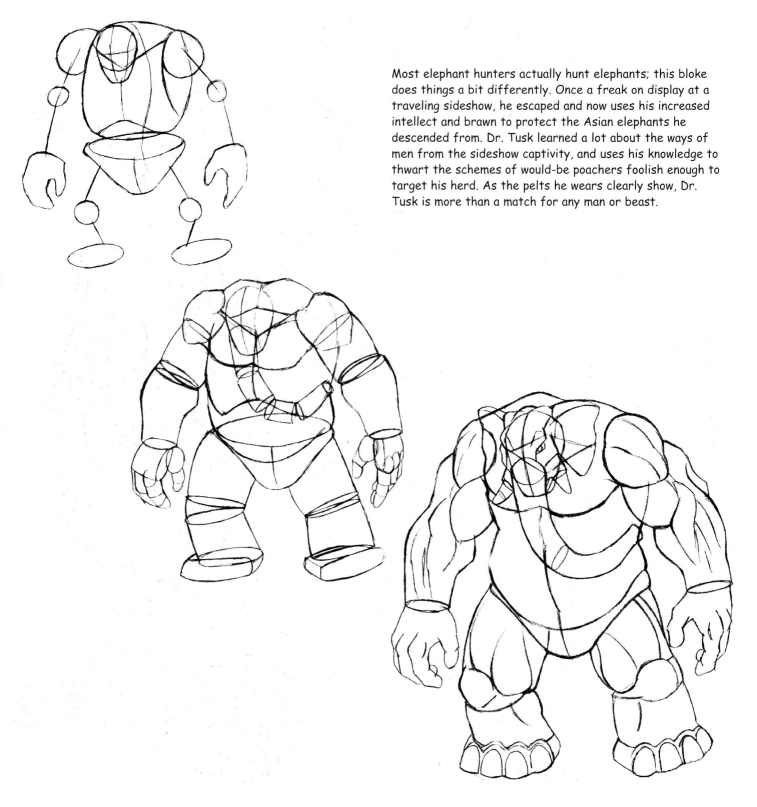

Most elephant hunters actually hunt elephants; this bloke does things a bit differently. Once a freak on display at a traveling sideshow, he escaped and now uses his increased intellect and brawn to protect the Asian elephants he descended from. Dr. Tusk learned a lot about the ways of men from the sideshow captivity, and uses his knowledge to thwart the schemes of would-be poachers foolish enough to target his herd. As the pelts he wears clearly show, Dr. Tusk is more than a match for any man or beast.

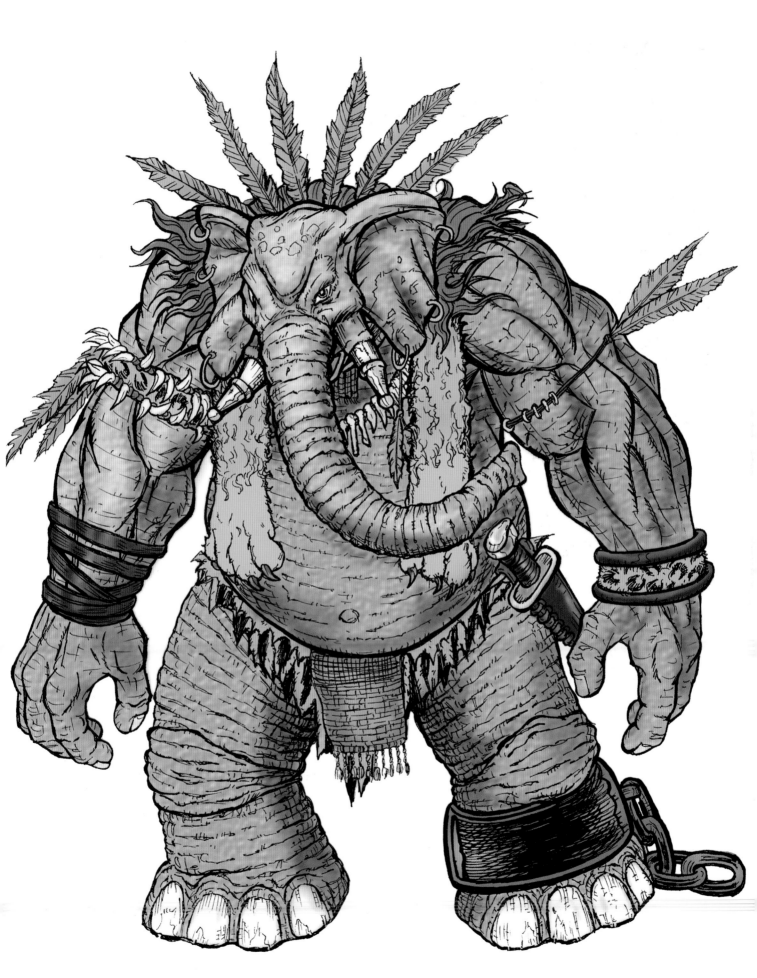

This drawing, which looks highly complex, will be a piece of cake if you follow the steps you have learned throughout this book. Sketch in the larger anatomical forms first. Don't worry about adding the ears and trunk yet, they will only overcomplicate the layout.

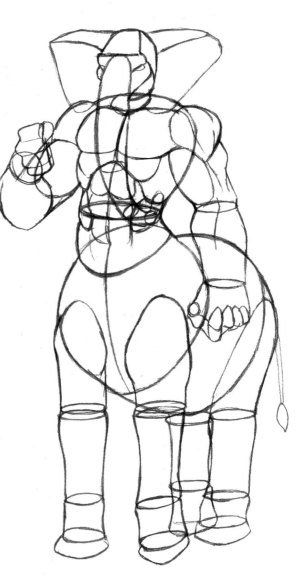

Concentrate on fleshing out your matchstick drawing before you move onto all the fancy weapons and accessories. These should be added last. The upper torso is built around the same chest structure used for all male characters. Be sure to exaggerate the size of the muscles so the character has symmetry between the upper and lower halves. The elephant's legs are cylindrical shapes, so make sure you draw them that way. They should bulge at the joints where the bones meet. The trunk is also basically a cylinder, but great care should be taken to draw it with a pleasing curve; an elephant's trunk contains no bones, just highly flexible muscles. Notice how changing the number of legs—four here for Elephantaur instead of Stampy's two—radically alters the appearance of our elephant man.

Elephantaur is big, bad, and ready for anything. All of the details befit this massive warrior, who is a much more regal character than Dr. Tusk.

Artist: Shawn Kirkham

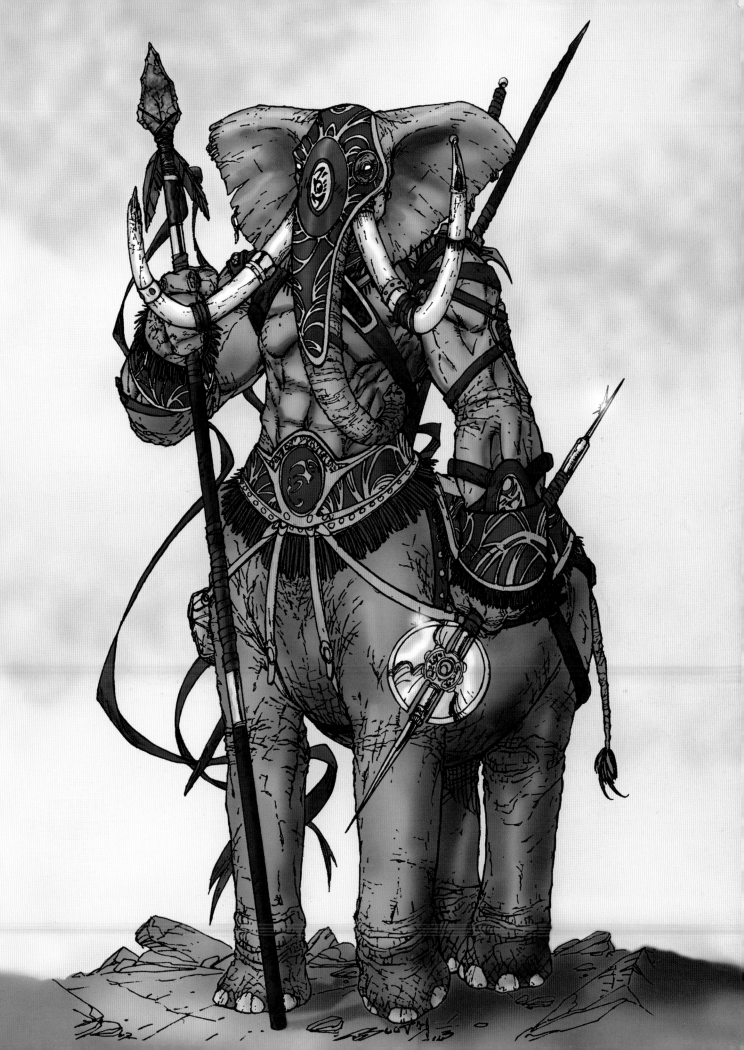

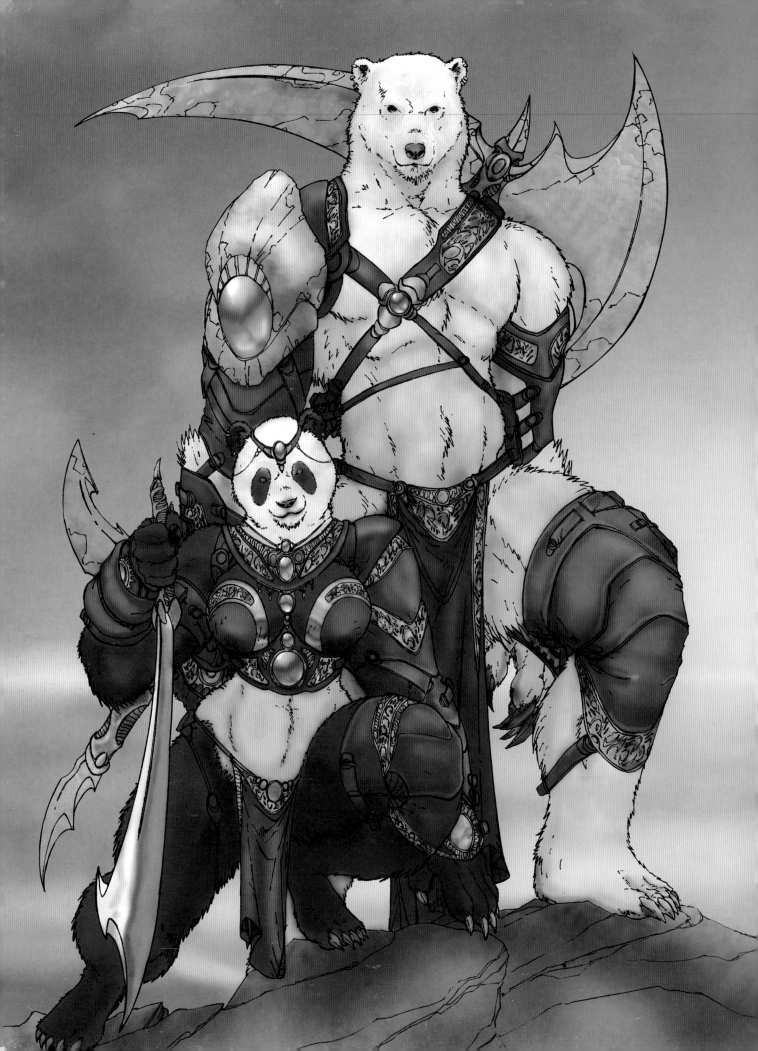

Da Bears

Bears are big, but most of them have an undeserved reputation for ferocity. Don't bother them and they won't bother you. Once provoked, though, they can be very dangerous indeed. Polar bears are armed with jaws like a steel trap full of incisors designed to slice through seal blubber like a hot knife through butter. If the teeth don't get you, they have two massive arms which they can swing like meat clubs tipped with four-inch claws. And they are *fast*. A polar bear can even outrun a caribou over a short distance.

OK, OK, these bears don't look very bad *or* ugly, but the male is *gigantic*. Female pandas are by no means small, but he towers over her like a giant. For characters based on male bears, think of the strong, silent type. He has the patience of a saint, restraining the furry of a demon. He is in no hurry to start trouble, but he definitely will end it. His companion Xiongmao (the Chinese word for panda, which means "giant cat bear"), like all giant pandas, is an even-tempered animal, the least aggressive member of the bear family. But don't think that just because they are basically gentle giants they are not equipped for war. Remember when designing panda-based characters like Xiongmao that they are the most lovable and adorable bear people you will ever meet who are able to disembowel you but probably never will.

Hyena the Hunter

African folklore is rich with stories of hyenas and their malevolent magical powers. For centuries, the hyena had the same kind of reputation in Africa as black cats did in some parts of Europe and America. Africans believed that hyenas could change sex at will, and that witches could change themselves into hyenas. Even people who didn't believe in witchcraft dismissed them as foul-smelling scavengers, and their maniacal giggling and growling around kills did nothing to improve their image. We now know that they are fierce and aggressive hunters who regularly compete with prides of lions when hunting live prey. Their ability to go without without water for days, plus incredibly strong constitutions (hyenas are even able to digest rotting crocodiles), make them perfectly adapted for life in harsh environments. By hunting cooperatively in packs they help keep that old "circle of life" spinning at a consistent speed.

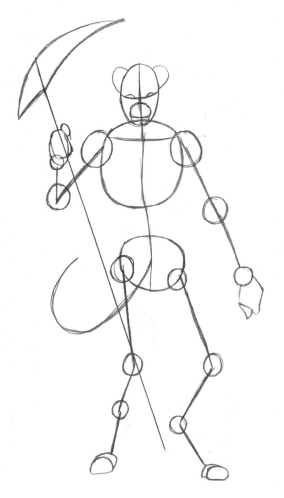

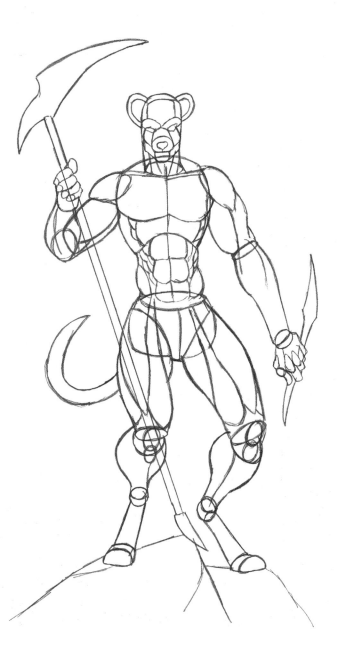

Draw your hyena character the same way you have been drawing your other characters: start with a rough drawing, fill out the muscles, add weapons, and put in details like spots and fur last. Meeting up with this hyena would be no laughing matter.

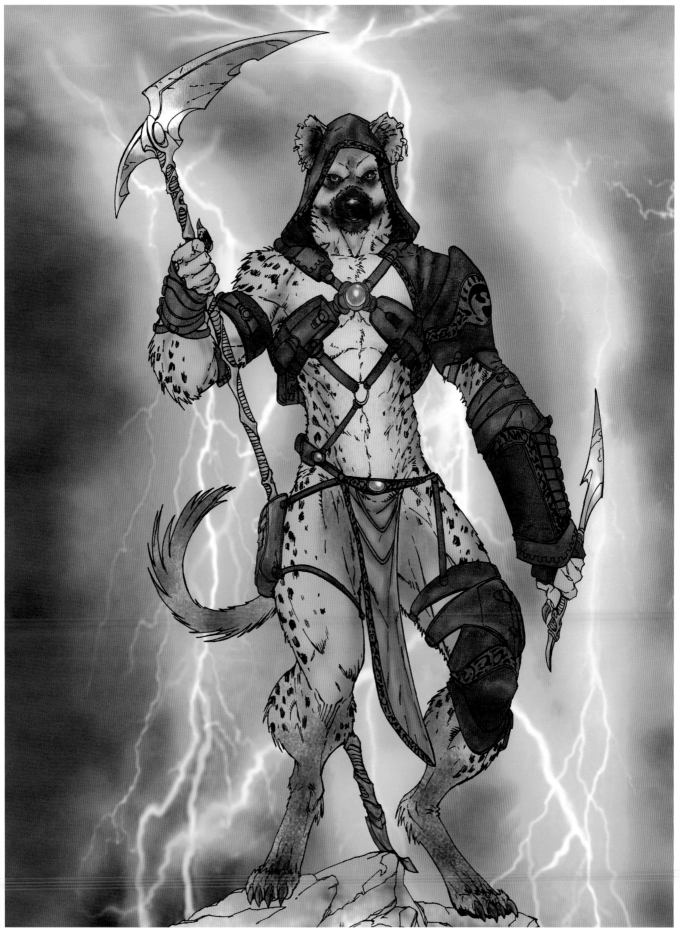

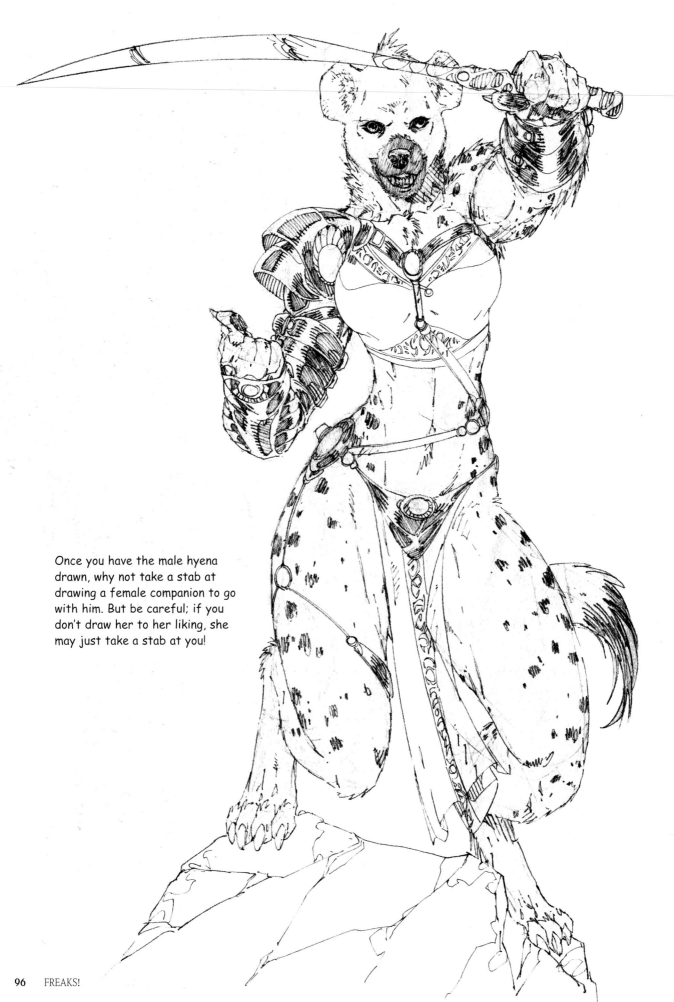

Once you have the male hyena drawn, why not take a stab at drawing a female companion to go with him. But be careful; if you don't draw her to her liking, she may just take a stab at you!

Rhino Warrior

Maybe you know this old rhino joke: A rhinoceros goes into a bar and asks for a shot of whiskey. The bartender thinks to himself, "He's a rhinoceros, he doesn't know the cost of liquor." So he charges him fifty bucks for the shot. As he pours the drink the bartender tries to cover up his deception by engaging in a little small talk. He remarks, "I don't get a lot of rhinos as customers around here." The rhino replies, "I'm not surprised, at fifty dollars a drink."

This rhino would not have been tricked so easily. Just one look at him and you know he is a bruiser who doesn't get taken advantage of. As if being huge, horned, and covered with an industrial-strength hide wasn't enough, this guy has the audacity to wear chain mail and studded straps. That is not an easy look to pull off. Believe me, I've tried.

BUGGING OUT

You don't have to go into space to discover the truly alien. You just have to explore the world underneath your feet. Live insects are as bizarre as anything Hollywood special effects artists could create. I mean what kind of animal wears its skeleton on the outside of its body? Bugs are also high on the DL (disgusting lifestyle) chart. If you have ever seen footage of how a fly eats you're no doubt grateful that they live life on a scale we can largely ignore. That is, until someone started playing with the old radioactive goop in the bug lab. Now the bugs are as big as NFL linebackers, running loose, and looking for a little payback for all the times a mean-spirited kid crisped one of their friends with a magnifying glass.

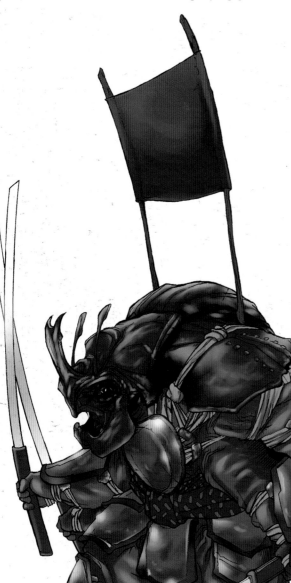

As always, no matter how complex your character is, he or she is invariably made up of the same simple shapes we looked at way back at the beginning of this book. Take some time to figure out what shapes to model the different parts of your character on. For Shogun Beetle, I used an oval shape sort of like a potato for the combined torso and waist mass.

Shogun Beetle
Sometimes the easiest way to design a character is to think about what shapes or objects in the macro world the creature's natural physical characteristics—no matter how bizarre—remind you of. Looking at the picture of a beetle one day, it wasn't hard to imagine its exoskeleton as some sort of strange alien samurai armor. The rest was easy.

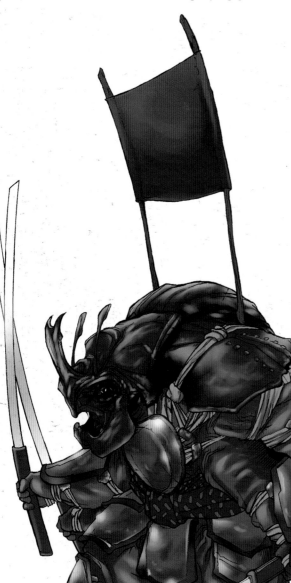

Artist: Mitch Byrd

Photo background courtesy of Heather Miller.

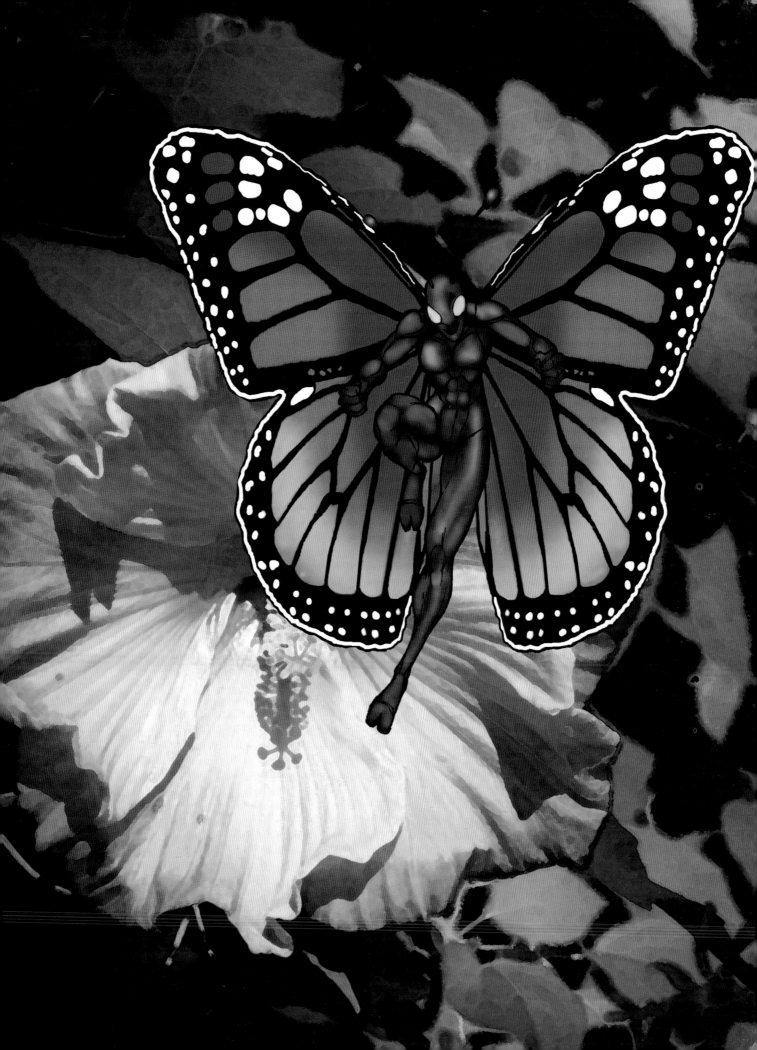

Butterfly Girl

Some insects are very beautiful. Here is a character I created for a comic about a group of miniature people who use discarded insect exoskeletons as armor (that is a nice way of saying they run around wearing dead bugs). When designing your characters, choose the animal elements that reflect the kind of role you have cast them in. For this woman I wanted a real butt-kicker who was at the same time sexy and feminine. I gave her a durable suit of exoskeleton armor, but I also equipped her with a nice pair of Monarch butterfly wings. Her appearance would be drastically changed if I had chosen dragonfly wings or planted a big nectar-sipping proboscis on her face.

Mantis-Man

The praying mantis is one of the most visually striking of all insect species. It received its name because it can often be spotted with its front limbs in the "praying" position, but it could just as be easily called a "preying mantis" for its keen hunting abilities. Mantids utilize their distinctive foliage-based coloring to blend in with their surroundings. Their unusual anatomy increases the effectiveness of their camouflage, allowing them to lie in wait for passing prey, disguised as a branch with a couple of leaves. These carnivorous insects will attack and consume prey nearly their own size. Martial art masters adapted the mantids' movements into a form of Kung Fu known aptly enough as Praying Mantis Kung Fu. Combine all these elements and you can design a pretty intriguing character.

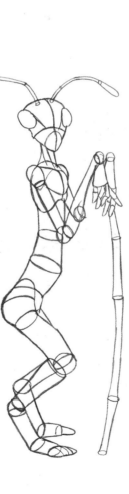

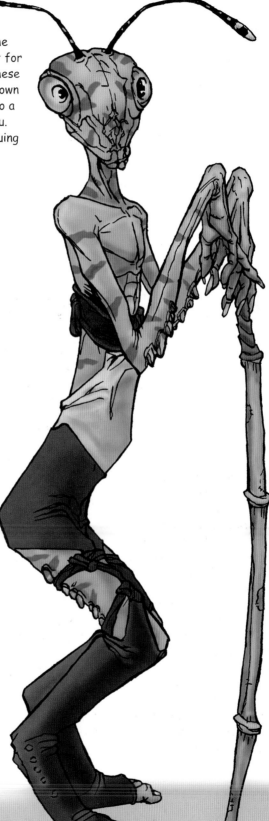

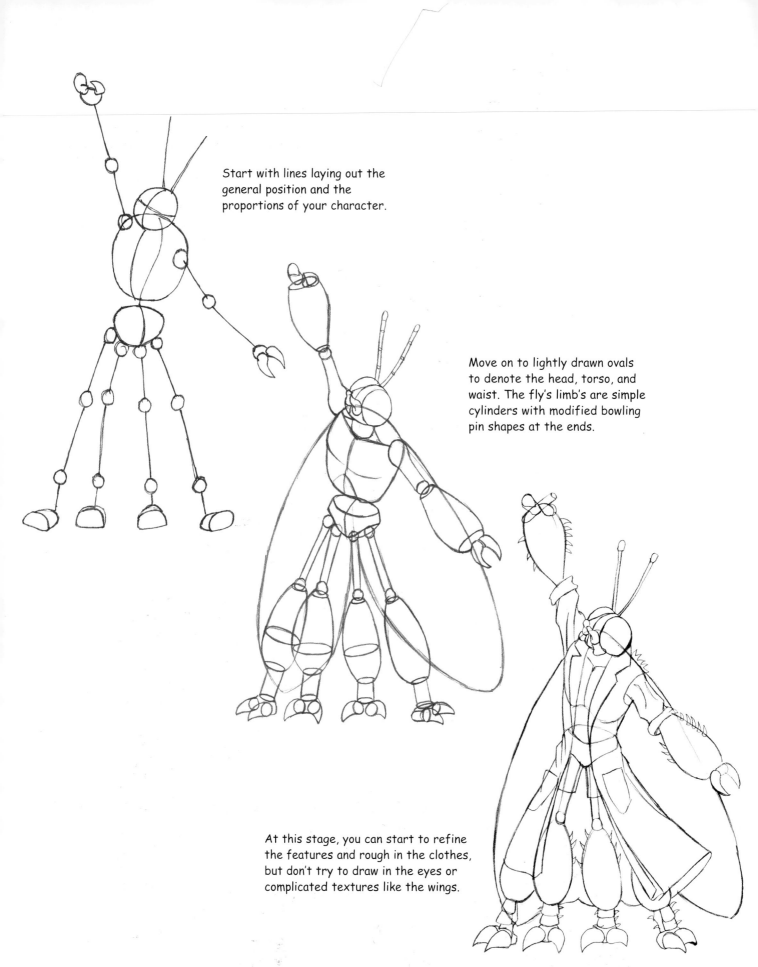

Start with lines laying out the general position and the proportions of your character.

Move on to lightly drawn ovals to denote the head, torso, and waist. The fly's limb's are simple cylinders with modified bowling pin shapes at the ends.

At this stage, you can start to refine the features and rough in the clothes, but don't try to draw in the eyes or complicated textures like the wings.

Fly Guy

This guy is a pretty good example of what can go wrong when you decide to use yourself as your own guinea pig. You can get mad and beat your wings furiously and pound your clawed tarsus against the wall, but you really have no one to blame but yourself. Calm down. It won't do any good to fly off the handle.

WINGED THINGS

In Greek myth, Daedalus was the brilliant artisan who built the labyrinthine maze for King Minos of Crete in which so many poor souls were devoured by Minos's Minotaur. Later, Daedulus did something to annoy the king, who had a short fuse, and Minos imprisoned the inventer and his son Icarus in a tower on the island. Daedalus fashioned them both pairs of wings constructed of wax and feathers, and they soared out of the tower. Before taking flight Daedalus cautioned Icarus not to fly too close to the sun. Icarus, intoxicated with his new ability, paid little heed to the warning. He flew so high that the blazing sun melted the wax, the delicate wings disintegrated, and the boy fell into the ocean and drowned.

So what is the moral of this story? Is it that with great powers like flight also come the need for restraint and the wisdom to use them? Or is it if you are going to fly it is better to radically change your anatomy at a molecular level rather than using shoddy building materials like wax? Either way, dreams of flight have always captivated the imaginations of scientists and artisans alike. It is what compelled the Wright brothers to construct their first glider and what inspired a couple of comic book creators named Jerry Siegal and Joe Schuster to come up with a character named Superman. Since Superman first came on the scene, flying men—and a few flying women—have been a mainstay of comics. They don't always have clean-cut good looks that allow them to blend into the population. Many are (need I even say it?)—freaks! The freakier the better, so sharpen those pencils and let's take a stab at drawing some flying monstrosities.

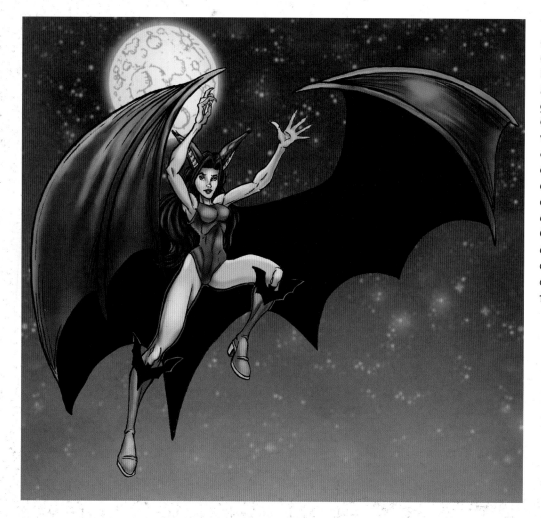

This young lady may be a creature of the night dedicated to wreaking havoc. But who knows? Maybe she has a heart of gold inside her goth shell. Characters who play against viewers' expectations can create a more interesting overall entertainment experience and up the ante on their emotional commitment to the story. On the other hand, there can't be a shadow of a doubt that her male counterpart—shown on the facing page—is pure evil.

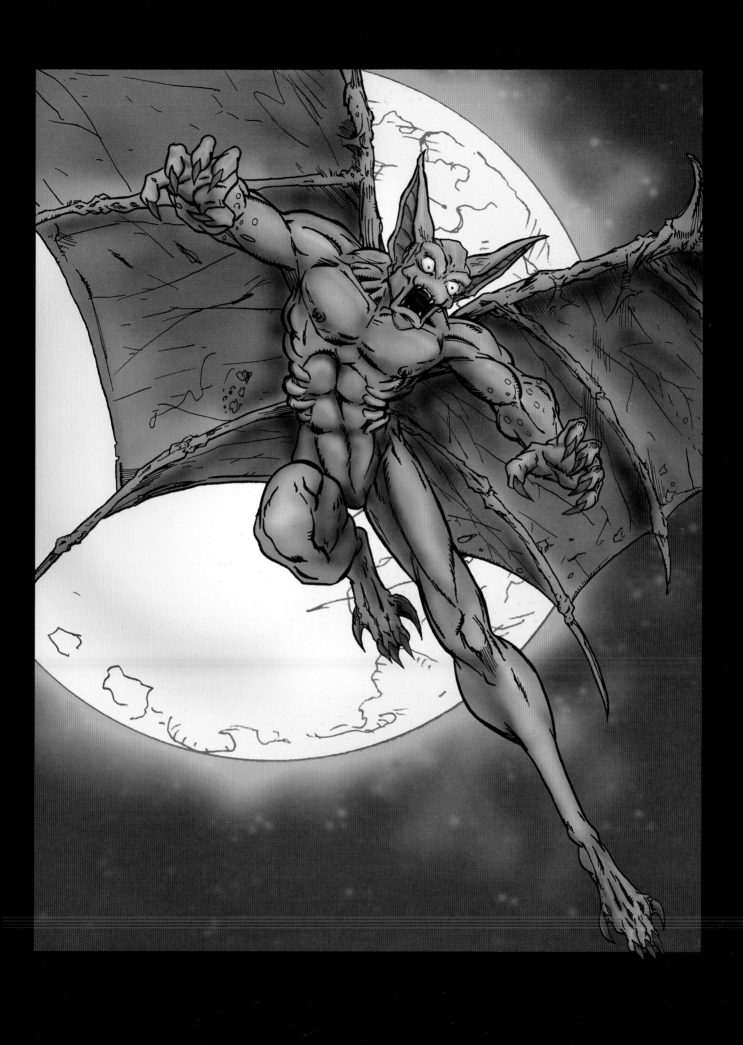

This guy isn't quite as mean and ugly looking as the bat guy on the opening page of the chapter, but he'll probably never be viewed as a hero and he most likely won't take up crime fighting as a career.

Wings are not as difficult to draw as they may first appear. See on the first drawing how I totally left out any indication of the wings at all? Instead I chose to sketch in the arms and "hand" shapes that form the frame for the wings.

In the second step wrap the wings around the framework you have created. Remember a bat's wings are thin, slightly elastic, leathery membranes. They tend to billow as they are filled with air during flapping. Bats are capable of moving each wing independently, so you should be able to create some truly dramatic aero dogfights filled with dynamic poses.

Pteri Man

The pterodactyls (or pterodactyloids) were a group of flying reptiles that terrorized the skies during the dinosaur days. They had a light frame and hollow bones, allowing them to remain aloft in even the slightest breeze. They had relatively large brains and excellent eyesight. Some had lightweight bony head crests that may have acted as a rudder when flying. I sketched Pteri Man while watching a dinosaur nature special on PBS. As an artist you never know what is going to inspire you or when the next great character design is going to come to you. Get in the habit of keeping a sketchpad and pencil always close at hand so you won't lose the energy of your initial creative spark.

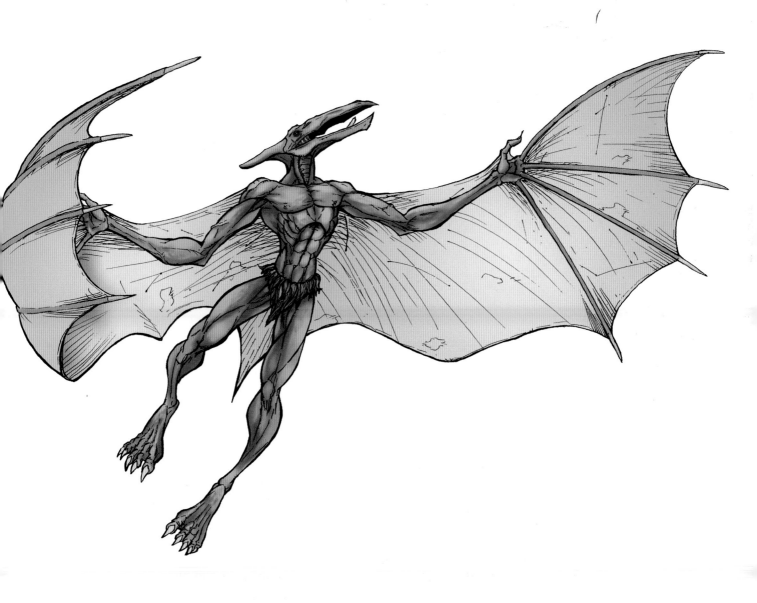

Birds of Prey

Hawks and eagles and over 200 other species of day-hunting birds of prey are elite members of nature's Air Force. They are talon-equipped raptors able to swoop from the sky to snatch their prey with only the slightest whisper from their wings. Hawks have such acute eyesight they can spot a mouse from over a mile in the air.

Ancient people assumed all birds were messengers from the gods since they shared the same sky. They used the flight patterns of birds of prey and their fallen feathers to try to divine the future. While this may seem to be pure superstition, the truth is that birds do react to changes in their environment that presage forthcoming natural disasters like earthquakes and storms.

This bird part of this guy is sort of a composite creation—hawk, eagle, maybe a bit of condor. Notice I sketched in the shape of the feathers, including the tail feathers, early on, to make sure I had exactly the proportions I wanted.

I've added in the basic muscles, as well as lines indicating the different layers of feathers.

Actually drawing in the feathers took a lot of extra work. Notice the small rings of feathers that top off his fearsome talons, a feature that I might not have added if I hadn't spent time looking at color pictures of some of the world's great birds of prey. The larger raptors are strong enough to carry off foxes, and my goal here was to convey their awesome strength. If you don't have a good book, go to the Internet. There are plenty of bird watchers out there who divide the bird world into two major groups—raptors and raptor food—and the number of raptor hits you'll get may surprise you.

Razor

Razor's mother knew that he would be different when his egg glowed in her nest. She was exposed to radiation at a nuclear plant near her nest and because of it Razor would have abilities like no other eagle. A scientist saved him and nursed him when a hunter killed his mother. Razor now glides through the air saving the world from evil with Gizmo the Fighting Ferret, a lighthearted foil to the often-serious Razor.

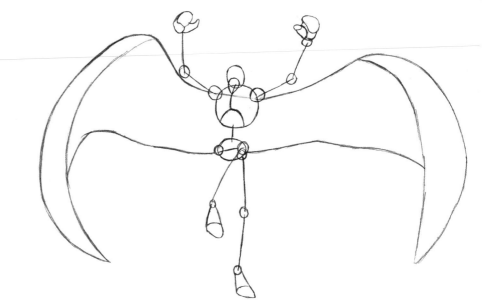

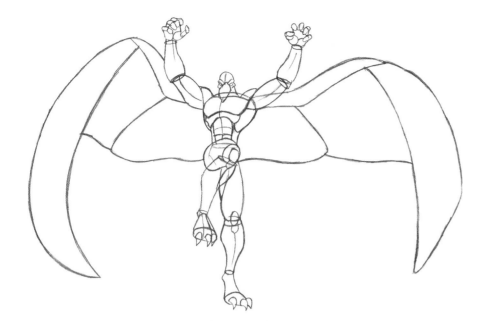

Razor is the brainchild of Jeff Luttrell, an exceptional young man I met early in my career when I was working at a toy company. Jeff, an avid toy collector, had lukemia. Eleven years old at the time, he had developed an idea for a mutated eagle superhero, and wanted to see concept become reality. Through the Make-A-Wish Foundation, a nonprofit organization that helps children with life-threatening illnesses, Jeff was able to fulfill his dream. On the basis of Jeff's concept sketches, the toy company I worked for spent a week creating a prototype action figure, and Razor was the result. Later, Key Bee Toys mass-produced Razor, who comes with his sidekick, Gizmo the Fighting Ferret.

When I started to design the eagle character for this book I immediately thought of Jeff and his wonderful creation. With a little help from the Make-A-Wish foundation I was able to track him down. I'm happy to report that today Jeff is healthy and strong. I feel privileged to have been able to work with Jeff once again, to share the fruit of his creative gift, and remind people everywhere that sometimes dreams do come true.

MONKEYING AROUND

Ever since stop-motion pioneer and filmmaker Willis O'Brian brought a giant ape to life in *King Kong* primates have been a staple of our cinematic fare. On screen, apes were not content to be endlessly hunted by man, and decided to take over the world in the *Planet of the Apes* films.

Higher-Order Primates

There are about 170 different species of primate. At the higher end of the order are the apes, including orangutans, gorillas, and chimpanzees. All three of the ape groups are highly intelligent, social animals, and gorillas, though they look fierce, are peaceful animals that live in tight social groups. Of all the creatures in the animal kingdom they are most like humans. Heck, some of them are so physically similar they could raid our closets and wear our clothes. Apes are in movies, novels, video games, and comic books. Roller-skating chimpanzees dressed in tutus or tuxes were long a feature of vaudeville and nightclub acts.

Monkeys are magical money-makers. There is a popular rumor that one well-known comic book company witnessed a 20 percent increase in sales whenever a monkey appeared on the cover. So keep practicing drawing these primates and let some of that monkey magic start working for you! Onscreen they may have eventually been defeated, but when it comes to pop culture we are still living on a planet of the apes.

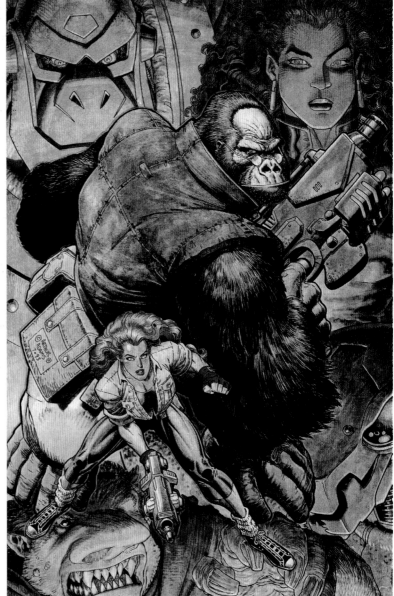

Arthur Adams channeled his love of the original King Kong into a highly entertaining series of comic books called *Monkeyman and O'Brian*.

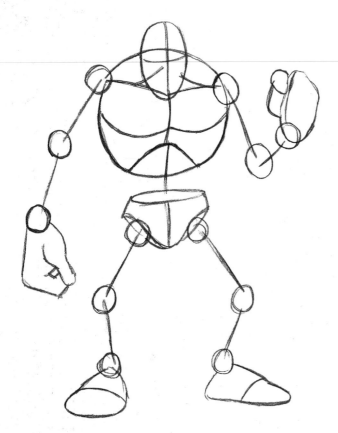

Gorillas are physically similar to humans and some of the other primates, but there are a few things you can do to make sure anyone seeing your character will instantly recognize him as a half-man, half-gorilla. Gorillas are the largest of the primates, with thick arms and legs and great, broad shoulders. Early on, you need to sketch in the lines to convey those characteristics.

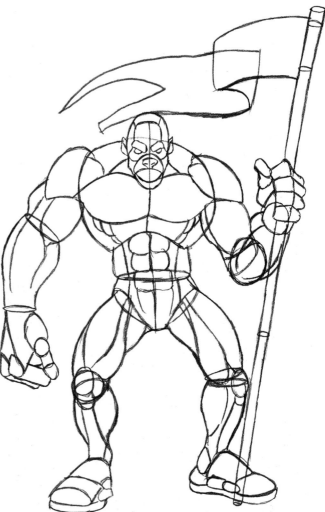

For this guy, you need to make sure his face is sufficiently gorilla-like, so check out some pictures or go to the zoo and sketch. You'll want to get the right shapes in *before* you do the final sketch.

Notice that the armor on his left shoulder makes that shoulder look even broader. The thick fur on his legs is also a characterstic of gorillas, but not the other primates. This guy is obviously a warrior, but you can give your character any personality you want. Scientists tell us the more intelligent an animal is the greater its fondness for play. Since gorillas are amongst the smartest, you could portray your mutant as having a great capacity for . . .well, monkey business.

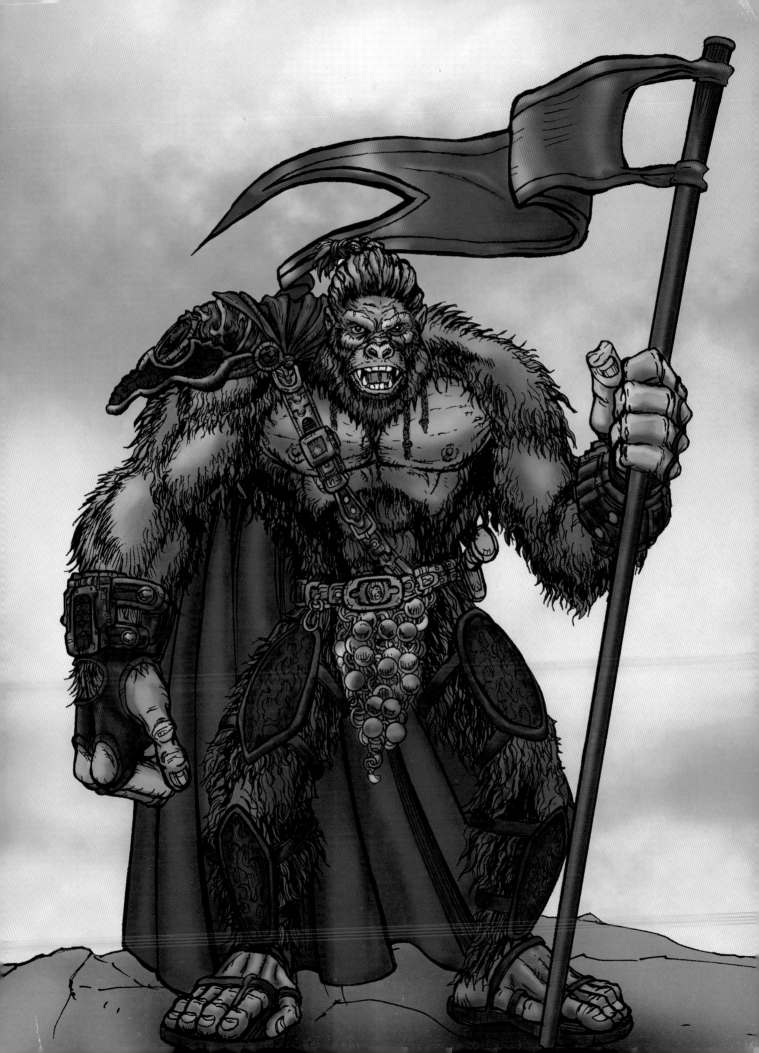

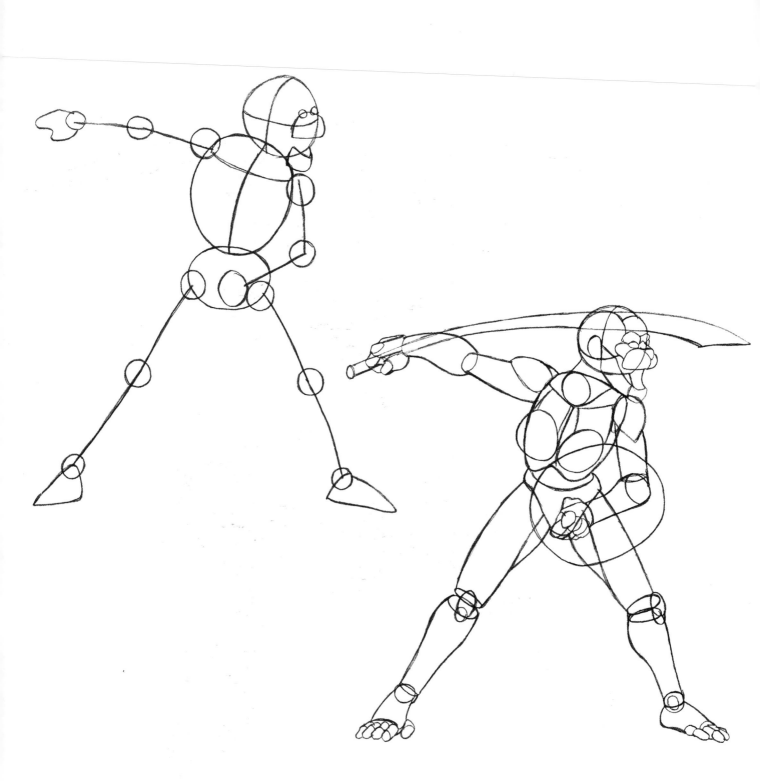

If things had worked out between King Kong and his blonde captive, their daughter might have looked something like Anex, Warrior Chimp! She is a true Amazon but hasn't lost touch with her primate roots.

Artist: Mitch Byrd

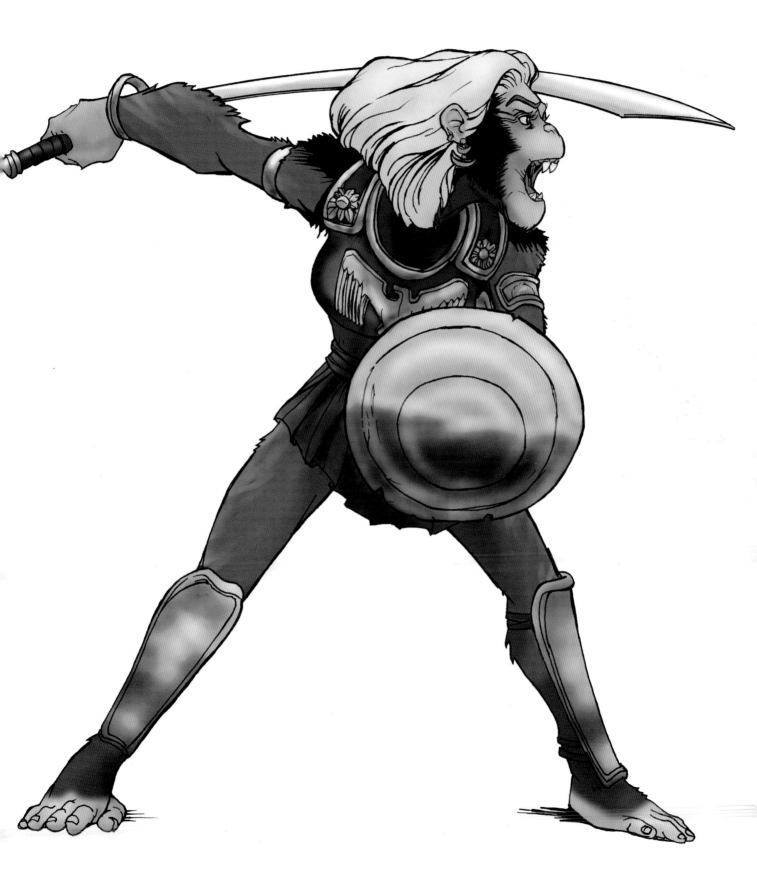

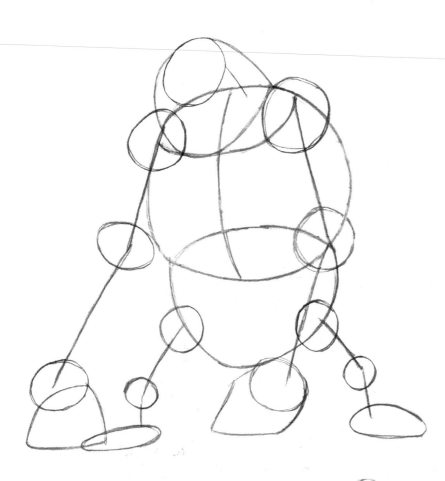

The artist must have looked at a lot of orangutan pictures before creating Pongo here. Unlike the warrior apes, he'd rather play than fight. Some anatomical details that are characteristic of orangutans have been exaggerated. Males have large cheek pad fat deposits that continue to enlarge as the orangutan ages. Orangutans have a high, sloping forehead and a bulging snout. They have short, weak legs, but strong hands and arms. Like all apes, they are quite strong and highly intelligent. Orangutans are maybe the only creatures on the earth with faces as rubbery as Jim Carrey's. Pongo is a bit of a caricature, but at the same time he's a fun, original character.

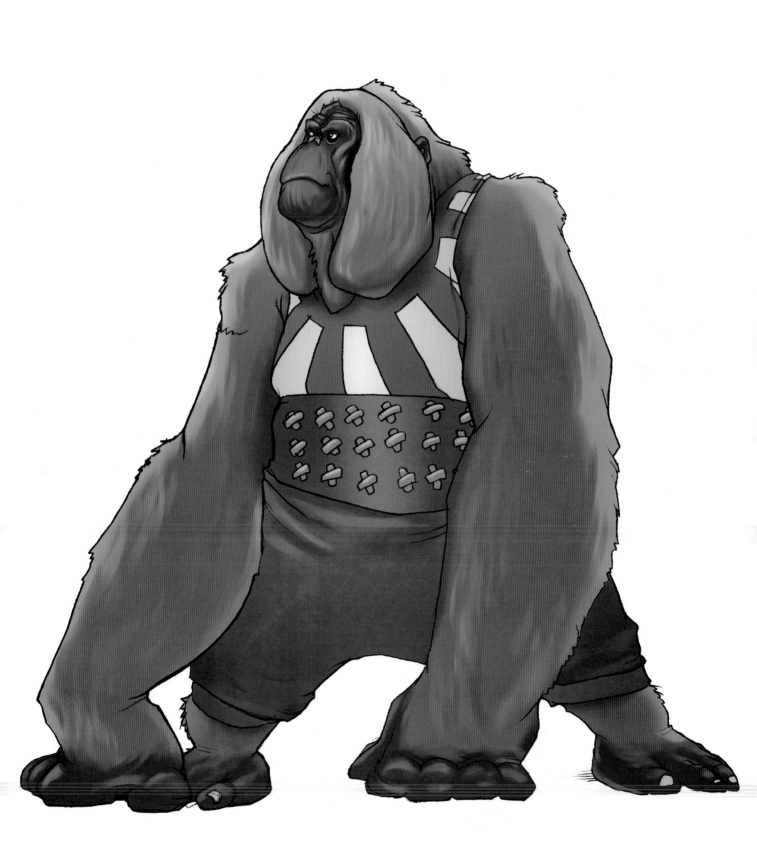

UNDER THE SEAS

Water covers about 71 percent of the planet, and at its deepest, the ocean floor is almost 6 miles below the surface. From the time that human beings first set sail right up to the present, scientists and sailors have speculated about what wondrous (or monstrous) life forms might lie below the waves. In 1555 the naturalist Olaus Magnus described a "very large sea serpent" 200 feet in length and 20 feet in diameter. Fifteen years later, on a map of Iceland, A. Ortelius drew in numerous fantastic creatures, including one that looks very much like a mermaid-centaur. Most people no longer believe in sea serpents or mermaids, but as technology advances and oceanographers are able to explore ever deeper who knows what they will discover?

Fish People

Triton is a merman, and there is no doubt that the first thing that comes to mind when thinking about undersea fish people is creatures with the torso and head of a human and the lower body of a fish. Mermaids, in particular, have occupied a special place in mariner folklore for centuries. Prolonged trips at sea took a heavy toll on a sailor's eyesight (and perhaps his sanity). Terrible monsters and charming aquatic maidens suddenly seemed to fill the oceans. Stories started filtering back of a beautiful undersea lady with the tail of a fish. Sometimes this beauty was portrayed as a mischievous little tart, trying to lure ships to their destruction, while other times she was rumored to be looking for a little romance.

There are, however, many other possibilities. You don't have to stick to the merperson model when you are creating your fish characters.

Triton
In Greek myth, Triton was the son of the Olympian Poseidon and the Nereid Amphitrite. Triton is supposed to be the guy who makes the ocean roar by blowing through his shell, and this character looks powerful enough to do the job. At the same time he is lean and lithe, able to to cut through the deeps at breakneck speeds.

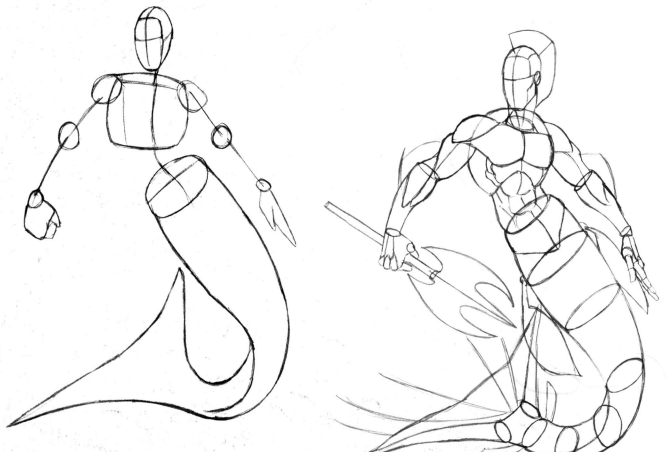

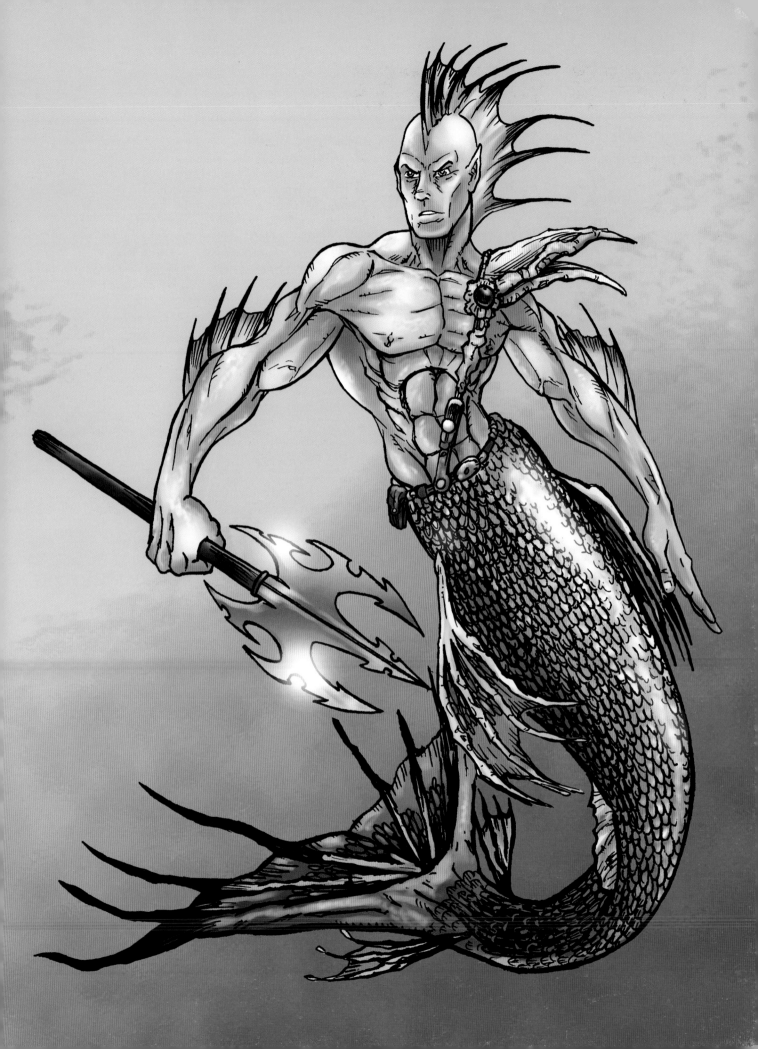

Goldie

Goldie is beauty and the beast in perfect balance. She has the face and torso of Seamate of the month, but all of her secondary anatomical features emphasize the wild side. Any fashion consultant will tell you that the secret to a successful wardrobe is in the accessories. I wholeheartedly agree with them, but whereas they are usually referring to the right choice of purses, shoes, and belts, Goldie's accessories are fins, tails, scales, and claws.

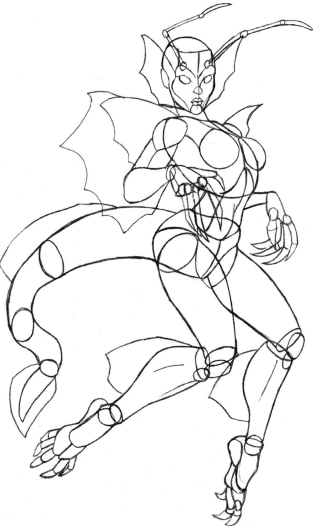

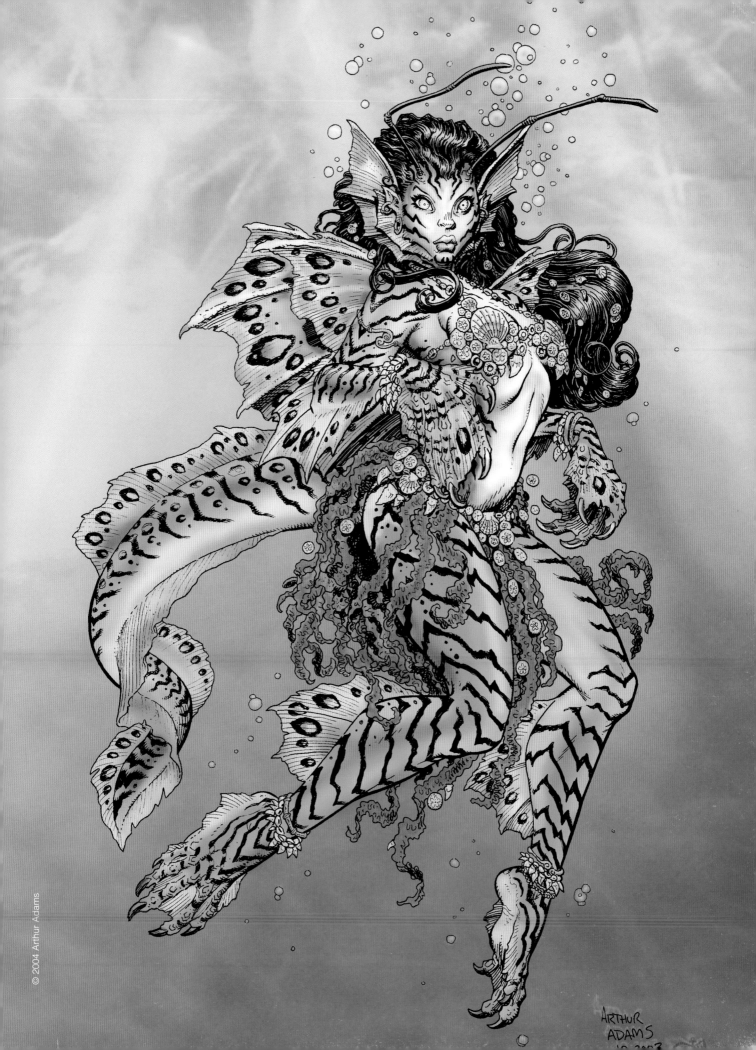

ARTHUR
ADAMS

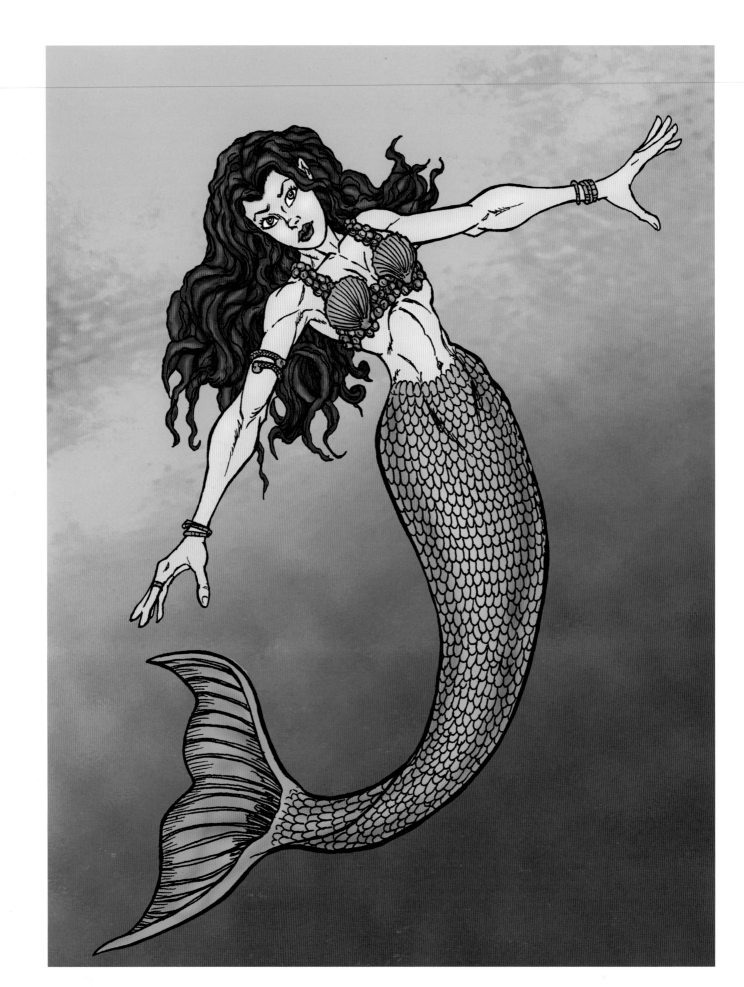

The Quintessential Mermaid

Keep your mermaid construction smooth and organic. She needs to be sleek like a dolphin (which is probably what those imaginative sailors originally mistook for mermaids in the first place!) to allow her to swim with speed and finesse. When she is not in motion, her hair should float up and away from her head, adding to her otherworldly charm. This character looks perfectly harmless, but never underestimate the power of a mermaid. And *don't* order fish and chips if you invite her to dinner.

Fishface

"Part man, part fish and all ugly" aptly describes this character. I pity the troller that accidently snags him in a fishing net. He's got the limbs of a man, but I've emphasized the more fishy elements. His face, complete with large eyes that will allow him to see in the murky depths, is *all* fish.

Other Denizens of the Deep

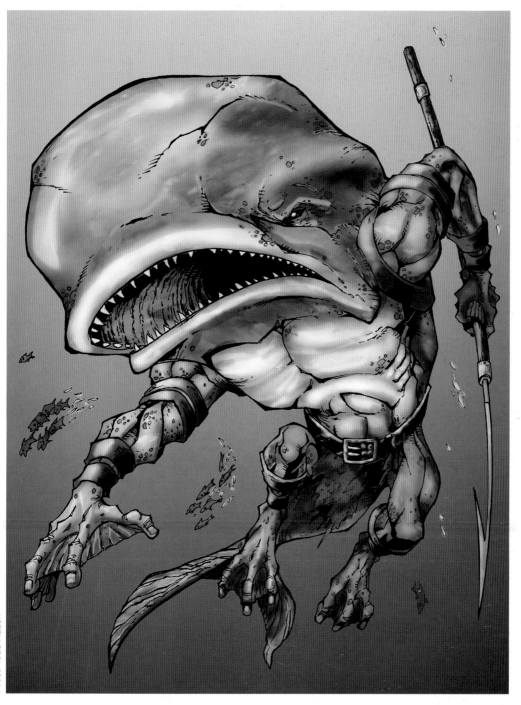

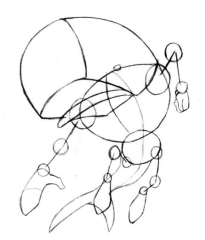

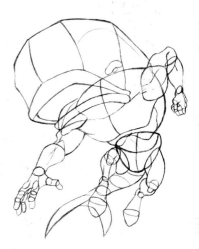

Artist: Todd Nauck

Moby, One Whale of Guy

Captain Ahab would have lost more than a leg if he had run into this Moby on his first fateful voyage. One look at him and the fiercest of pirates would have cut anchor and maybe even thrown the treasure overboard so they could beat a speedier retreat back across the seven seas. Moby is a unique combination of characteristics. Even though he is portrayed as being massive, you don't doubt for a minute he can effortlessly move about the ocean's depths like a living submarine.

Mako Bruce: The Shark Man

Mako Bruce is a man-eater for sure! Forget your typical sharking vessel if you plan on hunting this denizen of the deep. You're gonna need a bigger boat if you want to avoid being snared by his massive jaws. Sometimes what you leave out of a drawing is as important as what you put in. The cold, black emotionless eyes and expressionless face add to his overall inhuman nature. Add a gaping, toothy maw and you have the perfect eating machine.

Artist: Todd Nauck

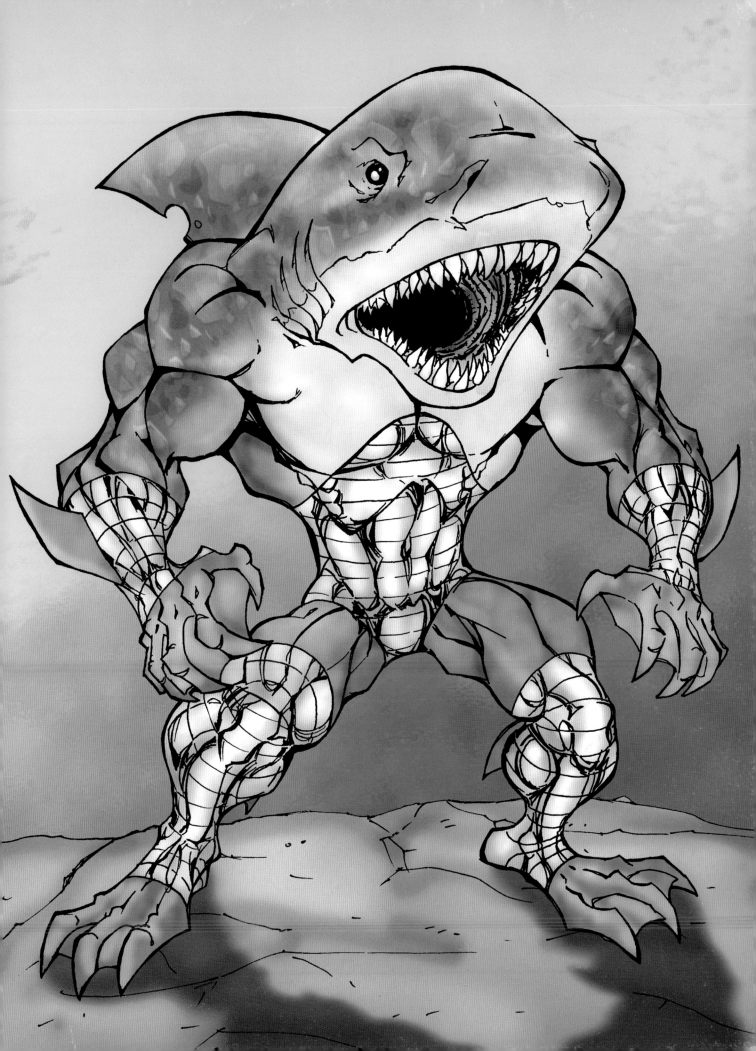

When drawing Octopus Man's tentacles, make sure to keep them organic and curved, no sharp bends. Use the same method that you have been using to draw your character's tails; lay them out with one fluid line. When constructing the final shape remember to use a cylinder as the underlying form. Each arm starts out thickest at the base and tapers off to a thin point at the end.

Don't worry about drawing all those suction cups until everything else is drawn correctly. It would be a real shame to have to erase all of those little suckers and draw them again.

Octopus Man

This guy is like a bad blind date. He is messy, has no backbone, and seems to be all arms! Don't let his appearance fool you though; octopi are highly intelligent creatures and have some amazing abilities. Their lack of a solid skeleton allows them to squeeze through remarkably small spaces. Defensively they can squirt a cloud of ink to confuse their predators and if they lose a tentacle in a skirmish they can grow a new one. A little-known fact is an octopus can change its colorings and patterns to blend into its surroundings like a chameleon. There is very little that this guy can't adapt to, except maybe getting dressed up for a glamorous night on the town.

SPORTS MASCOTS

Are you tired of your favorite team getting trounced? Do you want to give them that extra moral boost that will send them roaring into the winner's circle? Then how about designing a new team mascot that will send their opponents back to their locker rooms cowering.

Sports teams frequently tap into the wellspring of animalistic energy to create a winning image. Who wouldn't want to have the ferociousness of a lion, or the cunning of a cat, or the brute strength of a buffalo? Animals possess incredible athletic prowess, and a team's mascot can be a highly successful way to associate those advantageous qualities with a team.

As an artist it is your job to decide which animal attributes are most likely to convey the positive image of a champion. Intimidation is a powerful weapon on the court or field, so try to create a design that not only bolsters home team moral but also strikes fear into the visitor's squad. It is one thing to play against other mere humans, but to feel like you've been tossed into the lion's den with white-hot snarling balls of feline terror is another ballgame together.

In most cases you will be asked to provide a face-lift to a franchise's sagging public (and sometimes sadly, self-) image. There is nothing quite as invigorating as breathing new life into a worn out old flea-bitten mascot. Is the current logo dated and no longer relevant? Energize it with a fresh infusion of artistic vision. Maybe the team has settled for a generic off-the-shelf pose of a garden-variety tiger when a savage half-man, half-tiger snarling superathlete is what they really need.

If you are lucky you may get in on the early planning stages for the team mascot. It would be exciting to help choose a unique beast to boost local pride. The almanacs are already chock-full of lions, tigers, and bears, oh my! Wouldn't it be great to see some of the lesser-known critters get a little of the limelight? How about tackling the challenge of creating a team mascot based on a crustacean or a marsupial? Trying something new is a quick way of establishing the individual and cutting-edge aspects of the team.

Don't limit yourself by choosing from only those currently living species. How about selecting an ancient or extinct breed? A great example is the Toronto Raptors who successfully sparked the public's interest and admiration when they chose an unusual dinosaur design for their mascot. Don't stop there; explore the wonderful possibilities from mythological stock. Who wouldn't quiver with fear if a team of menacing Minotaurs thudded onto the field or who would venture into the pool against a swim team named the Howling Hydras? Be creative and don't be afraid to experiment with bizarre creations.

Here is the original logo. There is nothing wrong with it. It is a clear, precise image of a tiger for a basketball team. But there is nothing really unique that sets it apart from a thousand other teams known as the tigers. Now let's get creative. How much cooler would it be to see a tigerman soaring in for an Air Jordan style dunk?

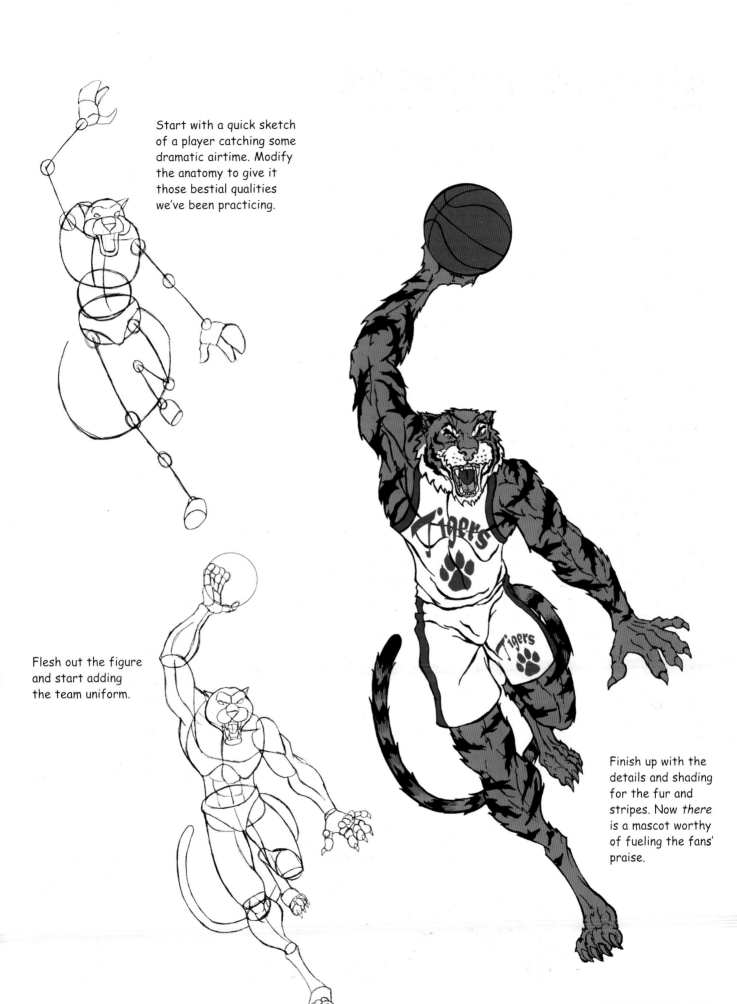

Start with a quick sketch of a player catching some dramatic airtime. Modify the anatomy to give it those bestial qualities we've been practicing.

Flesh out the figure and start adding the team uniform.

Finish up with the details and shading for the fur and stripes. Now *there* is a mascot worthy of fueling the fans' praise.

PLANNING SEQUENCES

Whatever sequence you are creating—be it a series of comic strip panels, the storyboards for a film or videogame, or the shot sequence for, say, a transformation—you need to present the sequence of events in a logical, internally consistent manner. Here we will take a brief look at some different approaches to transformation sequences, then turn to a comic book sequence that takes a lighter look at transformations.

Transformations

A transformation may be shown as a series of shots or panels that are obviously taking place over a few minutes or as something that happens in a split second. A transformation may also be presented as a gradual metamorphosis that begins early in the comic or film and goes on throughout the arc of the story. Whatever approach is taken, the scenes have to reflect what the change is doing to the character emotionally as well as physically.

For me, the all-time best transformation scene on film is the the first time special effects master Rick Baker shows us David Naughton's character David changing into a werewolf in the the 1981 film *An American Werewolf in London*. I imagine that the effect it had on me is what audiences in 1966 felt when they first saw Lon Chaney, Jr. make the same change in the classic Universal film *The Wolfman*.

In David Cronenberg's 1986 chilling remake of *The Fly*, the metamorphosis is gradual. Over the course of the film, Dr. Seth Brundle, played by Jeff Goldblum, slowly changes, body part by body part, from a good-hearted nerdy scientist into a grotesque abomination barely holding onto his last spark of humanity.

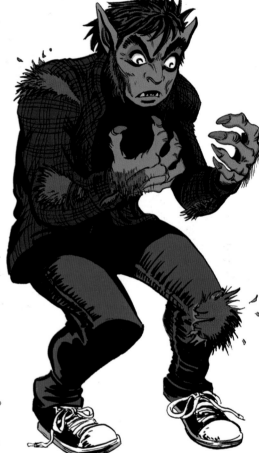

Artist: Bryan Baugh

In this four-image werewolf transformation sequence, the change is unexpected and it takes place over a short period of time. The character at first feels fear and confusion, then welcomes the rush of new animalistic power as it courses through his veins and he grows excited in anticipation of his new form. When the transformation is complete, the ravenous werewolf, his eyes glowing, is ready for action.

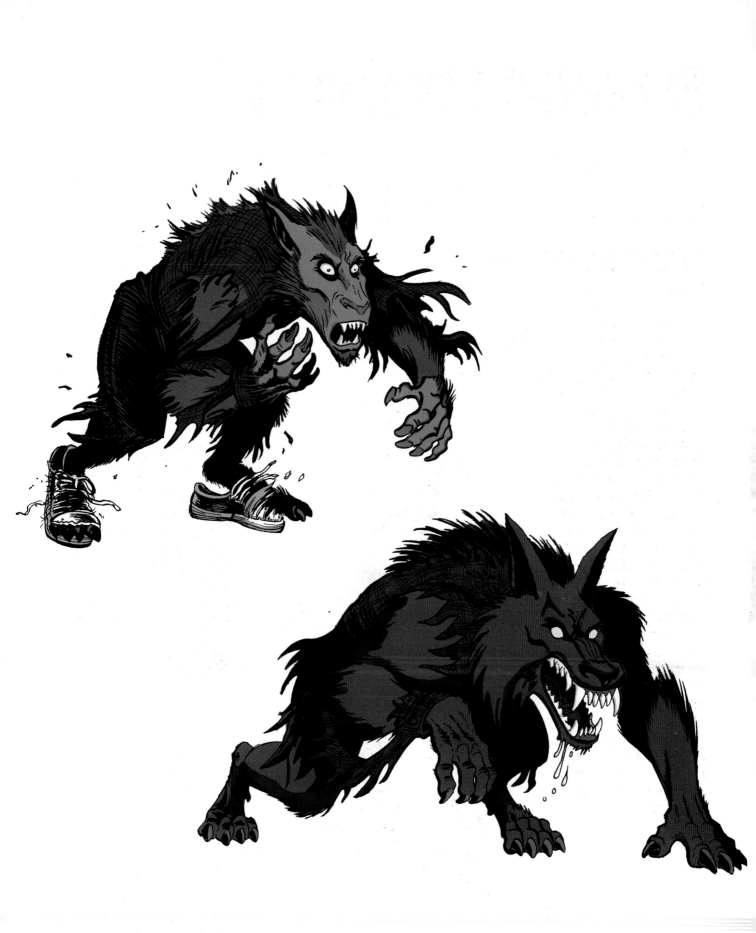

Laying Out a Panel Sequence

Here I use a couple of comic book pages showing a typical event in the life of your friendly neighborhood mad scientist to illustrate a classic approach to laying out panels.

The first panel, usually an oversized splash panel, like this one, is what is known as an establishing shot. Establishing shots give visual clues showing where and when the action is taking place.

After you have established the when and the where, it is time for you to introduce the who. This is where we meet your character for the first time. He may be the protagonist (the hero) or the antagonist (the villain); it is too early to tell.

As the character moves indoors, as an artist it is your job to again establish what the new locale looks like. Don't stint on research. If the setting is supposed to be a modern high-tech research facility you don't want it looking like Frankenstein's gothic laboratory.

As you draw each panel choose perspective shots that keep the reader's eye moving across the page from panel to panel. In panel 2, for example, the light from the office on the floor moves the eye down and right. In panel 6, the character's elbow moves the eye down, and in panel 7 the diagonal with the fuzzy hair on top moves us right.

Take advantage of the fact that when reading comics, people have to turn pages. Utilize the transition from one page to the next at key plot points. In the last panel on this page, something big is happening but we don't know what it is.

The smaller a panel is the faster a reader's eye will move over it. To slow down the pace increase the size of the panels and decrease the number of panels per page.

As the action progresses your staging of each shot should become more dramatic, like these three. Use your eye just like a movie camera to pick out the best composition for each shot. Vary the angle and perspective for each panel. Nothing is more boring than panel after panel of repetitive scenes.

The final panel is what is known as a "money shot." A money shot in comics is visually compelling, so that if someone were flipping through the book in the store and saw it they would be convinced to spend money on the book. In the world of film, the term is more literal. It's proably a special effects shot that the director is going to pour a big part of the budget into. The bottom line: either way it has to be cool.

Artist: Mitch Byrd

WHAT YOU'LL NEED

Having the proper tools and a spacious, well-lighted workspace can be very important whether you are a beginner or a seasoned pro.

Workspace

If you are serious about drawing, you will spend hours upon hours in the same place, with the same chair, work surface, and lighting, so set up your workspace carefully. Find an area in your home where you are the most comfortable and free of distractions. Make sure you keep all of your materials at arm's length so you do not constantly have to stand and search for them. To minimize the strain on your back you will want your work surface to be high enough so that you do not have to hunch over it. Ideally you should have a fully adjustable drawing table, one that allows you to vary the angle of the drawing surface. How you adjust the table will depend on what feels right, but you need to see your entire sheet of paper. It is better to work on a tilted surface than a flat surface; this helps minimize eye fatigue and helps keep unwanted distortions out of your drawings.

A swivel chair with adjustable height is perfect, but get one without arm rests, as they will only get in your way. For most people, the right height for the chair is one that allows the forearms to be parallel with the floor when their backs are straight and their hands are resting on the table. Otherwise any comfortable chair will do. When drawing or coloring your work, be sure to bend your waist, not your back. Good posture will prevent back strain and allow you to work for several hours without discomfort. If you find yourself leaning over your drawings, try raising the drawing surface or lowering your seat

The ideal light, of course, is natural light from a skylight. Failing that, a good fluorescent desk lamp is fine for sketching and inking. Strong incandescent light is a better light source than fluorescent or halogen when you are coloring your character, as the same color can appear very different under different kinds of light. (If you don't believe me, try an experiment: look at a piece of cloth in a bright solid color first in sunlight coming through the window, then under incandescent light, then under fluorescent light. You'll be amazed at the difference.)

Supplies

Experiment with lots of different types and brands of paper and paints until you've got a pretty good idea of what works best for you. Here is a little bit of free professional advice: Constantly running back and forth to the store to replenish favorite supplies is a huge time waster, so when you find something you like, buy it in bulk (if your budget allows) and horde it like a greedy miser.

Paper

The paper you use for sketching does not need to be high quality or of heavy weight. The only real requirement is that you have lots of it! I use a plain package of 8½ x 11-inch white recycled printer paper for all of my sketching needs. You may want to purchase a special sketchbook so you can keep all of your drawings together. Once you are ready to produce final illustration-quality pictures, you will need to purchase some higher quality paper. I use two-ply Bristol board for all of my final drawings.

Pencils

The harder the lead of the pencil you are using, the lighter the line. Pencils with harder leads (labeled H to 9H) also tend to make deeper indentions in paper, especially lightweight sketching paper, and most pencilers prefer softer leads (from HB to 9B), which make a darker line on the paper. I use an HB or 2B pencil for most of my drawings. If you don't have access to special art pencils don't worry; the old garden-variety #2 yellow pencils used in schools all over the world are perfectly OK for sketching.

When you are sketching in your initial drawing to get basic shape and proportions correct, you may want to use a special kind of pencil called a nontransfer or nonrepro pencil. These make very light blue or green lines that do not show up when a drawing is photographed or photocopied. You can do your early sketch with a nonrepro pencil, then draw over it with your normal lead. This is especially helpful for beginners, or when laying out a complex scene with several characters.

Erasers

If you are really serious about becoming an artist, you should lock up all your erasers, throw away the key, then start sketching. Kidding aside, you do need to practice pencil control; make your lines initially very light, then gradually darken the ones that look best. If you make a mistake, leave it; just draw the correct line right over the one that isn't right. If you make too many mistakes, get another sheet of paper and start again using the old one as a reference. Don't be overly concerned with making your sketches look perfect; after all, they are only part of the learning process, not the final product.

Down the road, of course, you'll need to do some erasing. All you need are two basic types of eraser: a kneaded eraser, which looks like a grey chunk of silly putty, and an art gum or white plastic eraser. By "patting" your drawing with a kneaded eraser, you can lighten a-too-dark line without damaging your paper. Use either an art gum or white plastic eraser when you want to completely remove a mark.

Hard
9H
8H
7H
6H
5H
4H
3H
2H
H
F
HB
B
2B
3B
4B
5B
6B
7B
8B
9B
Soft

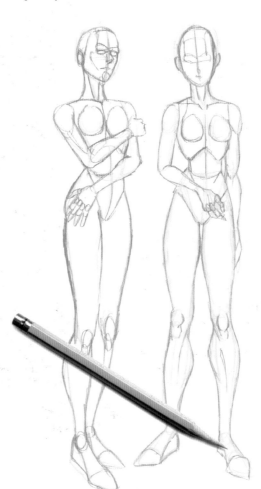

Pens and Ink

Final illustration-quality drawings will almost always be completed with some form of pen or marker to ensure clear and permanent line quality. There are almost as many "favorite" pen-and-ink combinations as there are artists, and you'll need to experiment to find what works best for you. Technical pens come with their own ink reservoirs, and so are less messy to use than dipping nib pens, but there is no substitute for having a set of nib pens, with different size nibs, if you are serious about learning to make a variety of different-width lines. Some inkers use Pigma or Sakura brush pens. I use both nib pens and technical pens to finish my drawings.

Getting the Exact Line or Shape

You'll need to have a few *straightedges* for making straight lines. At least one of them should be marked off in inches and centimeters. Metal rulers with a thin strip of cork on the back are ideal for inking because the raised surface keeps the ink from bleeding underneath the ruler and onto your drawing.

French curves, which can be found in any art supply store, come in various configurations, but all are designed to help you form smooth curved lines. You lightly sketch in the general shape of the curve you want, then lay the French curve over your marks. Move the French curve around until you find the curve that is the closest to your initial marks, then draw in the precise line. (Look at the white lion on page 45. If you don't feel confident enough in your drawing ability to sketch in a luxurious, curvy mane like his, you can use a French curve as an aid.)

Templates are like stencils and they come in a wide variety of shapes and sizes, from simple geometric shapes to elaborate designs. If you plan on doing a lot of comic book work, you can use templates to make perfect oval or round word balloons.

Light Boxes

You may also wish to invest in a lightbox. Lightboxes are illuminated from within, and when you place a drawing on the surface of a light box, the light shining through allows you to trace what you need onto a new sheet of paper. Light boxes aren't cheap. I built my first light box out of a deep dish cake pan with two plain fluorescent tube lights and a piece of Plexiglas. It worked great until I could afford to buy a commercial one.

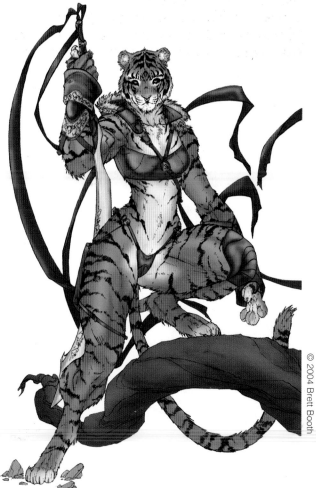

When you pencil tight and detailed lines, you don't have to ink over your final drawing. This tigress was initially laid out with a 2H pencil. Then the artist went back in and darkened the final lines with an HB. The final drawing was scanned into a computer and colored directly over the pencil lines.

INDEX